SCULPTURE IN SIAM

SCULPTURE IN SIAM

BY ALFRED SALMONY

ASSISTANT DIRECTOR IN THE MUSEUM
FOR FAR EASTERN ART IN COLOGNE

HACKER ART BOOKS
New York
1972

First published by Ernest Benn, Ltd.
London, 1925
Reprinted by Hacker Art Books, Inc.
New York, 1972

Library of Congress Catalogue Card Number: 79-143362
ISBN: 0-87817-081-2

DEDICATED TO RICHARD SAMSON

CONTENTS

LIST OF ILLUSTRATIONS

LIST OF ILLUSTRATIONS

LIST OF ILLUSTRATIONS

LIST OF ILLUSTRATIONS

LIST OF ILLUSTRATIONS

INTRODUCTION

An attempt to follow out the history and development of Art in Siam appears feasible only in the case of sculpture. Works devoted to its architecture have hitherto served only to show how difficult it still is to trace the evolution of such an art without adequate excavations. Well-meaning preoccupation with modern products, overlaid as their style is by mere manual dexterity, is bound to be hopelessly misleading. Painting no less than architecture is confined to comparatively recent monuments. Pictures of the 16th or 17th centuries, such as those in the British Museum, are to be regarded as exceptionally early in date. For all that, in these examples, especially in the treatment of landscape, Chinese influence is already noticeable—an influence Siamese sculpture in general knows nothing of. We owe the fact that in this case it is more or less possible to attempt a history of style to the preliminary studies of E. A. Voretzsch (*Ostasiatische Zeitschrift,* 5, 1–4, 6, 1, 2; and *Rupam,* No. 3) and to those of E. Lunet de Lajonquière (*Bulletin de la Commission archéologique de l'Indochine,* 1909 and 1912), which are, however, mainly geographical in their aim. In these essays Siamese sculpture is seen to be primarily a successive series of different styles. The major part of the material utilised in the present study has been brought to light on the spot by Voretzsch. Such remains as are still left above ground in Siam are little to be trusted and belong mostly to late periods.

Works by Siamese experts on the art of their country would seem to be multiplying steadily in number, but extracts and hints in K. Döhring's *Buddhistische Tempelanlagen in Siam* (Vol. I, Berlin, 1920) afford slender hopes of assistance towards a History of Art. Only such pieces as are authenticated by Voretzsch in regard to origin can provisionally be utilised as a basis for a history of style, for a strict embargo on export makes impossible any substantial enrichment of European collections. It may appear surprising that, in consequence, comparatively small examples are cited as valid evidence of development. These, however, possess the same degree of authority as the big figures, and show the changes of style more sharply than stucco colossi hastily wrought and meant to be seen at a distance. Works in bronze of larger bulk have not, it would seem, generally speaking, come down to us from early times without baffling restorations.

In the country itself climate and vegetation have not proved so destructive to Sculpture as the disturbances of war and pious attempts at restoration. The latter render many ancient monuments useless from the point of view of a history of style. The custom of laying aside sculptural relics in " Prachedis "—the architectural receptacles of the Temples—may even yet preserve many a valuable example for investigation. Finally, ever since the middle of the last century ancient remains have been brought into Temples, the origin of which has been lost. It having thus become feasible to fix the type of a local school, an example discovered elsewhere can be assigned without hesitation to the corresponding group. The preliminary work must in the first place be devoted to the acquisition of fixed concepts, but without being laid down too rigidly, and other local varieties must

be excluded. Moreover, the style of one locality may later on be found represented elsewhere. Like any other initial investigation, this, too, is subject to the danger of over-hasty classification. The risk is run deliberately as a part of the bargain.

May numerous corrections and more extended researches supplement the present work, and may museums and collectors help to guard against the worthless commercial manufacture of Buddhas in modern days, and substitute designations capable of definite critical proof for vague indications of locality.

With the exception of pieces to be found only in Siam, all the examples reproduced here could be examined in the original, so that it has been practicable in almost every case to give details of size and material.

The author gratefully acknowledges the kindness with which various material has been placed at his disposal. He is indebted for Plates 23, 29 B, 40, 44, 50 A and B, 68, to the Musée Guimet in Paris.

For Plate 56 A, B, C, D, to the Rijks Museum, Leyden.

For Plate 69, to the Museum für Völkerkunde (Museum of Ethnology), Leipzig.

For Plates 41, 42, 61, 66, to the Photographic Section of the Kunstgewerbe Museum (Museum of Arts and Crafts), Cologne.

For Plates 27 B, 31 B, 2, to M. H. d'Ardenne de Tizac, Paris.

For Plates I B, 3 A and B, 4 A and B, 5 A and B, 7, 19, 24, to E. A. Voretzsch, Lisbon.

For Plates 18, 27, 49 A and B, 57, 63, to A. M. F. Ponto, Lisbon.

For Plates 8 and 48, to M. O. Miestchaninoff, Paris.

For Plate 70, to Professor Dr. F. Sarre, Berlin.

For Plate 64, to M. Giraudon, Paris.

For Plates 46 B and 66, to Messrs. Glenk-Worch, Berlin.

For all the rest, to the Museum für Kunst und Gewerbe (Museum of Arts and Crafts), Hamburg.

The whole work has been made possible only by extensive and unselfish assistance of Dr. E. A. Voretzsch.

SCULPTURE IN SIAM

CHAPTER I
PRELIMINARIES

Our conception of Siam corresponds to a geographical, but not to an historical unity. The present-day kingdom has for its centre the Menam Valley and Delta, includes the major part of the southward running Malay Peninsula, extends east and north-east to the upper course of the Mekong, and on the north, east and west its natural boundary is a series of hills in the shape of a horseshoe which belong to the highlands of Tibet. Thanks to its favourable conditions this region was an ancient seat of civilisation. Yet no race, no nation, ever took permanent root in it; on the contrary, so frequently do peoples and principalities change in the Menam Valley that the several details of its historical evolution can only be delineated in rough outline. Local tradition, which often refers to works of art, is to be regarded as mainly legendary, in so far as it is not confirmed by inscriptions. The discovery of the only trustworthy epigraphic material is due to M. Schmitt (in *Mission Pavie*, Vol. II, Paris, 1898) and L. Fournereau (*Le Siam Ancien*, Vol. I, Paris, 1895). But these scholars, viewing the question from the philological standpoint, lacked the artistically and historically trained eye necessary for the classification of such monuments.

From such works of art as are found on Siamese soil it is often impossible to discover the racial affinity of their authors. This fact renders any historical classification by style especially difficult, whereas the European investigator is accustomed to look upon monuments as manifestations of a single race in its own particular habitat.

On Siamese soil such a mode of procedure would be practicable only if the peoples of Upper India as a whole be taken as the originators. Siam would then appear as a part of the artistic province confined within the limits of Upper India. This generalised and uniform treatment of the subject was originally aimed at. But material from Burma and Laos is at the present time procurable only in insufficient quantity; consequently an examination of the more thoroughly explored districts must inevitably be the first step. At any rate, the natives of Siam belong, and have always belonged, to the Upper Indian family of peoples. An exact description of the several races recognisable in Siam in the course of history has so far proved beyond the powers of anthropology. Even in the case of more completely explored Cambodia much uncertainty exists in this respect (cf. Groslier, *Recherches sur les Cambodgiens*, Paris, 1921, p. 9). In Siam, no less than there, a continuous admixture took place that hardly admits of resolution into its elements.

The racial evolution of the Peninsula is unthinkable without immigration from Lower India. In this connection it is of no importance whether the land or sea route was the more popular. This colonisation, however, in the 5th and 6th centuries, contemporary therefore with the genesis of the earliest monuments, was bound to exercise a definite influence upon the population and lead to the formation of a civilisation capable of further development. Even earlier it was an established fact throughout the Peninsula, for in the eastern part an inscription was found of

the 3rd century A.D. (F. Leuba, *Les Chams et leur Art*, Paris, 1923, p. 22). In the West it may be dated almost a hundred years later (M. L. Finot, " Inscriptions du Siam et de la Péninsule malaise," *B.C.A.I.*, 1910, 2).

European enquirers are too apt, in speaking of the influence of Lower India, to lay stress on its Aryan elements (A. Grünwedel, *Buddhistische Kunst in Indien*, Berlin, 1900, p. 4: " The whole civilisation of India is the work of the Aryans "). In historical times the intermingling of the light-skinned Aryans and the dark aborigines had undoubtedly advanced far, in spite of the caste system. Above all, the Aryans must not be held responsible for the great artistic achievements. No doubt they were the creators of the prodigiously elaborated systems of metaphysics that elucidate the inter-relations of the Ego and the Universe, and provided perhaps a constructional mental basis. But sculpture and Temple decoration were the work of inferior castes, dark-skinned Hindus, not gifted with the Aryan power of dominating life and mankind, yet possessed of a genius for artistic creation that taught stone, clay and bronze to mimic the luxuriance and natural growth of tropical lands. Thus, if in the Deccan, in Upper India, in Java and Ceylon, the early monuments obey an invariable law of similarity, if bodies display all the fullness of the bud and the flexibility of feline form, this is due to the circumstance that the inhabitants of these regions, geographically closely connected, were likewise racially akin. The religious basis of their ideal of beauty was naturally and necessarily bound to lead to like solutions. The intellectual framework of their art, the iconographic forms, may be referred back to the influence of the Aryans and their powers of ratiocination. Even they availed themselves, in fixing their ideals, of a racially cognate method—the Gupta-Hellenistic current, a border phenomenon of the Punjab, in the 1st to 5th centuries A.D. But it was a turbid stream, as was inevitable in the fate of this unoriginal, mechanical school, widely detached from its native soil and not rooted in any genuine impulse. The art of Gandhara, save for certain works of greater intensity, is for the most part dominated by empty formalism. It is important in the history of Buddhist art merely because it established the framework upon which the creative force of all Asia was in later ages destined to build.

The great reaction of the dark-skinned people against Gandhara, against creations their own race had not originated, constitutes the art of the Gupta period in India (4th to 7th centuries). This art predominates wherever stable conditions of life had as yet been established, and therefore also in those countries into which no Gandhara influence had yet penetrated, namely, in Siam and Java. But there the Gupta wave betokens not reaction, but awakening, the stirring of incipient activity, the free creative impulse of the race. The full-blooded sensuousness of early art stands everywhere in India side by side with the speculative world of its religions, remote from actuality and often a negation of life.

The oldest documents on Siamese soil are Sanskrit inscriptions; the earliest goes back to the 3rd century A.D. and is Brahmanical (Fournereau, *Le Siam Ancien*, Vol. I, Paris, 1895, p. 66). Consequently the earliest writing is one of the imports

from Lower India. Though no epigraphic monuments of Buddhism have hitherto been found extant before the 7th century (Fournereau, *ibid.*, p. 97), its first introduction should be assigned to an earlier date. Primitive Brahmanism had so far only a few sculptures of an early date to show, so that it is hard to say to what extent it has influenced the artistic creations of Buddhism. Nevertheless we may infer from the example of the neighbouring countries of Cambodia and Champa that the means of expression of both cults were identical. A characteristic of Upper Indian iconography is the extensive inter-penetration of the two religious systems. Buddha appears ranked among the gods, by the Brahmins, while side by side with " The Enlightened " are found Vishnu and Shiva. A stone tablet testifies that one of the most pious of Buddhist rulers (Fournereau, *ibid.*, p. 173) ordered Brahmanical sculptures to be erected. Thus, art in Siam is, even more than in Lower India, the outcome of the creative gifts of the people and only objectively conditioned by the religious systems.

The fact that the arrival of the peoples who subsequently intruded into the Hindu colonies of Upper India further reinforced the cult of " The Enlightened," is explicable on social grounds. The caste system connected with Brahmanism weighed heavy on the colonial immigrants; Buddhism, on the contrary, never troubled itself about races and classes of mankind. The arrogant conquering races must always be credited with a subordinate part in the building up of Brahmanism; the Buddhistic Way of Salvation easily satisfied the needs of the stronger. The Buddhism first attested by Sanskrit inscriptions belongs—the script suggests this—to the Great Vehicle (the Mahayana). This school was particularly addicted to material representations of the spiritual truths which it inculcated, and this accounts for the abundance of the monuments. On the other hand, the ever-increasing invasion, throughout the 10th to 12th centuries, by the Thai (the " Freemen," the present-day Siamese) from the north introduced the old Buddhism of the Little Vehicle (the Hinayana) and the Pali canon into the country. In the 13th century the Thai are lords of the Peninsula; about 1350 they make Ayuthia their capital. In 1361 a king ordered Pali texts to be brought from Ceylon, the treasure-house of the old original cult. With the 14th century, therefore, comes the definite and final victory of the Hinayana. Eastern Asia witnessed the degradation of the pure doctrine by popular systems, while in Lower India Buddhism vanished altogether after the 7th century. The fate of this religion in Indian colonial lands thus deserves special attention precisely by reason of i singularity. Pali-Buddhism, however, does not, even in Upper India, revert to the indifference to Art originally described. This is proved by the large number of sculptures dating from this flourishing period of the Thai kingdom (the 14th to 17th centuries).

CHAPTER II
LIGOR

Before and during the Gupta period adventurers and sectaries left Lower India and hoisted sail for the East, the land of fabulous riches. Indian emigrants—cut off from the great bulk of their fellow peoples—were thus bearers of the Gupta renaissance that affected the whole Orient. They gave the impulse to civilised life in Upper India; Art followed their doctrine and their script.

Still, it is difficult in Siam, where excavation is unknown, to refer works of art to these beginnings. This might be practicable, at earliest, with sundry small Buddhistic votive tablets. The surprisingly early date can frequently be confirmed by inscriptions (cf. R. O. Winstedt, *Malaya*, London, 1923, pp. 157-8). The Museum für Kunst und Gewerbe (Museum of Arts and Crafts) at Hamburg possesses an example (Plate 1 A), unfortunately without inscription. It comes from Nakhon Sri Thammarat, later known as Ligor; that is to say from the east coast of the narrow tongue of land which was particularly well adapted for a settlement on the sea route. In spite of injury, the group of six figures is clearly recognisable. In the middle is the Buddha, seated in European fashion (Sanskrit: Prahambapada asana), two attendants stand at his side, overhead appear three small seated Buddhas. The attitude of the principal figure is characteristic of the early Hindu period. It occurs in the south of the Peninsula and in Java, where, indeed, it can only be referred to the earliest period (Examples: the Buddha of the Mendoet, K. With, *Java*, Hagen, 1920, Fig. 41, and a small bronze, *ibid.*, Fig. 12). The attendants, presumably a pair of Bodhisattvas, have the Gothic swing of the hips. This accentuation of the limbs, this charm of rhythmical movement, is characteristic of Gupta art in the caves of Elora in the Deccan, of Elephanta near Bombay, in the caves and on the rook-walls of Mavalapuram on the Coromandel coast. In the case of the above, as in the other examples from the district round Ligor, the similarity to Indian prototypes is so great that the possibility of their having been imported must be taken into account.

This same art has spread northwards over the delta at the mouth of the Menam. Ayuthia possessed a slate torso, which had probably been imported, like so many antiquities in early times (Plate 2). The arms were set in socket-holes and are missing. The standing figure may be recognised as Buddha by the entire absence of ornament and by the sacerdotal folds or creases of the neck. The clothing fits close to the body without pleat or fold, looking like drapery only when it passes over the arms. It ends very high in a little roll, above which two folds of the neck are just visible. This treatment of the drapery is typical of early Gupta art (cf. V. A. Smith, " Indian Sculpture of the Gupta Period," *O.Z. Jahrg.* 3, Part I, Fig. 9). In Sanchi another sitting Buddha can lay no claim to any special indication of drapery between the neck and the seam of the sleeve (Photo, Goloubew, No. 60944). If the Indian prototypes date from the 5th to 6th century, then their reproduction on Siamese soil must belong at latest to the 7th century.

CHAPTER III
PRAPATOM

FIRST STYLE

Prapatom comes next after the scattered colonies of the south as the oldest centre of Siamese civilisation, "The First of All" (so translated by Fournereau, *ibid.*, p. 53), situated in the southern part of the Siamese mainland a little to the north of the mouth of the Menam. Moreover, it is to be supposed that the relative positions of land and water have shifted in the course of years, so that in earlier times Prapatom was probably a seaport. Among its ruins were found the dated Brahmanical tablets mentioned above. Works of art of the same period and religion do not exist, yet decorative sculptures in relief have been dug up at Prapatom, all of which are Buddhistic. Voretzsch, Lunet de Lajonquière and Fournereau have already drawn their conclusions in reference to these specimens.

One of the oldest marks of Buddhism is the use made of the lion, which appears mostly under the guise of guardian. In a slightly modified form of ornamentation the animal sits in the rectangle formed by a studded border in an example from Papatom (Plate 1 B). The background is filled in with a leaf design in spirals. The same rhythmical pattern of line marks mane and tail and follows the curve of the neck and thigh. Compared with the Javanese examples (With, *ibid.*, Fig. 33), the representation is a fairly moderate one on Siamese soil. It remains altogether in the Indian tradition. The accessories do not belie the Gupta movement. The creature shows how intimately this art is connected with the Açoka civilisation.

Among the leading examples of the oldest group are wheels, several of which are preserved intact (one, see Plate 3 A). We have here to do with the Wheel of the Law, a symbol which in Lower India (Amaravati, cf. V. A. Smith, *A History of Fine Art in India and Ceylon*, Oxford, 1911, Plate 33, 1) had already come to typify the Buddha. A pedestal with lotus flowers and volutes of leaves carries the disk aloft with sculptural effect. In the centre the sacred flower is again indicated. At first spokes and rims are merely ornamental, independent of any element of significance. The studded fillet on the edge of the felloe and between the leaf-work volutes of the outer rim and the inner side appears twice. The spokes are pillars and carry a capital, which repeats the spiral curves of the leaf motif. As at Amaravati, this wheel marks a significant central point in Buddhism, not a Brahmanical piece of decoration (somewhat the same as at Konarak, cf. Smith, *ibid.*, Fig. 138, as Fournereau, *ibid.*, p. 132, admits), although it may possibly have belonged to an out-of-doors structure.

An architectural fragment (Plate 3 B) shows decorative elaboration. The stone beam in question may have belonged to a recessed corner. It rests on a leaf ornament and is filled out with a continuous wreath pattern that surrounds a cluster of blossoms in alternate rounds and lozenges. Inside, the spaces are covered with a design of twisted leaves, while the extremities are continued above and below in the shape of the studded border. The decorative continuity is abruptly broken by a row of leaves, while a studded border forms a collar to the monstrous (Makkara)

7

head that projects above. The fearsome creature springs forward, exhibiting in the upper jaw three teeth and a tusk, below two teeth and an upward curving volute for a tongue. The mouth is filled by the Rahu, a demon with outstretched claws, tangled hair, staring eyes and bared teeth, a richly ornamented bridle round the neck. Similar attendant creatures have in all parts of Asia been borrowed by Buddhism from Brahmanism. A water-sprinkler from the Borobudur (With, *ibid.*, Fig. 3) shows the same general arrangement, but gives fresh significance to the Rahu, making him subserve a constructive function; he appears only as supporter beneath the Makkara head. Teeth, studded border and jaws are less overloaded in Prapatom with ornament than in Java. In a later piece from that island (Ardjoen Temple, With, *ibid.*, Fig. 61) only the open mouth with the Rahu suggests the memory of the more naturalistic model that had meantime fallen entirely into disuse.

The decorative scheme of the Makkara-beam ornaments the pedestal of a figure relief (Plate 4 B). The preaching of Buddha is represented. Fournereau's assumption that it may be concerned with a Brahmanical representation of a king is contradicted by the lotus footstool and the canonical absence of ornament in the figure of " The Enlightened." His right hand is raised in the attitude of exposition, Vyakhyana mudra; this Sanskrit expression would seem, according to A. Coomaraswamy, *Catalogue of the Indian Collections in the Museum of Fine Arts*, Boston, U.S.A., 1923, to take the place of the hitherto (A. Foucher, *Etude sur l'Iconoqraphie Bouddhique de l'Inde*, Paris, 1900–1905, *op.* 68 *sqq.*) accepted designation, Vitarka mudra. As in the Hindu clay tablets, the European sitting posture must be regarded as pointing to Southern Siam, where this posture continues till comparatively recent times. Two attendants, one of whom is half hidden by a cloud, appear to be holding fly-switches. The auditors grouped on either side are clearly distinguished (on the left squat beardless aborigines, on the right long-bearded Hindus with tall top-knots). The grouping is more compact than in the Borobudur relief, but in the execution of the significant details breathes the same freshness of observation.

In another fragment (Plate 4 A) the lotus, serving as pedestal for the standing figure of Buddha (mutilation renders the gesture of the hand uncertain) grows from the Rahu head. This is purely decorative in intention, and nevertheless more decipherable than a cognate example in Java (Kalasan, date 778, cf. With, *ibid.*, Fig. 80, and Plaosan, With, Figs. 46–48). It is in the ornamental emphasis of the monster's moustache that the pedestal comes nearest to the Kalasan example. The attendants carrying torches or fly-whisks are still closely crowded up round the Buddha.

The pieces so far discussed are clearly distinguished from cognate examples in Java. The composition is simpler, the relief does not melt away so much in the flat. The facile disposition of spaces, the sure handling of movement, serve to express only a meagre articulation. Whereas even the earliest examples from the island (from Kalasan up to the Borobudur) are overloaded with ornament. By comparison with Java the style itself compels us to assign an earlier date to the Prapatom monuments, some time in the 7th century.

PRAPATOM

SECOND STYLE

The elements of Hindu-Malay decoration, the whole stock of formal motifs, are found fully developed in Siam. Comparison with the districts of Upper India inhabited by a like race, and above all with Java, permits us, despite scanty material, to arrive at chronological grouping.

The stage corresponding to the Javanese monuments is represented by a wheel (Plate 5 A). The same elements of ornamentation already noted are multiplied and enriched. The feet of the spoke-pillars in their three divisions are decorated with a leaf motif covering the intermediate spaces. The capital at the top is emphasised by the studded ornament. The centre is filled in with two bands of lozenges and a leaf pattern as the leading motif. In comparison with the first wheel from the same field of discovery, the flat part is more richly overlaid with ornament, the plant decoration more strongly marked. A similar treatment is shown in the stone pedestal (Plate 5 B). The crouching Rahu is surrounded by two pairs of leaves, which, as in the Kalasan example (With, *ibid.*, Fig. 48), cover the surface almost without a break, but are partially interrupted, for instance, by the rectangle. The older ornamentation (that of the lion-relief) was confined within the frame; the developed type extends beyond it. The volutes round the lion, in contrast to the leaf ornament round the Rahu, left the background plain. The latest art of Prapatom is closely related to the Kalasan, and therefore of similar date (8th century).

Whether further finds of stucco monuments from the same locality are to be assigned to the same period depends purely on considerations of style without reference to their place of discovery. The objective significance of the head (Plate 6 A and B) raises difficulties which only comparison with Java can solve. A particularly curious effect is the framing of the forehead in a sort of kerchief, a lap of which descends to the ears, while another covers the centre of the brow. This motif makes a solution of the riddle possible; probably we here have a head of "The Enlightened," intended to bear a rich, princely ornamentation on a kind of cap or pad, a head-dress often met with in the Borobudur reliefs (cf. With, *ibid.*, Fig. 22, and N. J. Krom and T. van Erp, *Barabudur*, The Hague, 1920, Vol. I of Plates, Series 0, Plate 6, No. 43, and Plate 19, No. 148). The loss of the crown in the small example emphasises the simplicity and the personal accentuation of the expression of absorption perhaps more than belonged to this work of art originally. The heavy lids lie like curtains over the eyes. The noble nose is evidence of a man of energy and action. The incomparable mouth, whose lips have tasted of life's pleasures, are tightly shut, as though in pained satiety. Every peculiarity of the stucco head is found in the throned Prince of the Borobudur relief, who, gazing inwards, turns away from the delights the fairest women offer him. It is not the physical characteristics of the Malay race that are reproduced naturalistically, it is from the underlying nature of the living model that the artist's memory has created, omitted, reinforced, exaggerated, and in the end wrought so convincing an image of the essential idea which he was trying to express—renunciation

of the world—that the small fragment achieves a significance quite as great as that of the more expatiatory relief. Like the latter, the stucco head has had a decorative function, and even though no surrounding figures pictured the incident, the wise-hearted renunciation of the Bodhisattva, rising superior to life, is manifestly the subject of this design. Similar pieces from Prapatom are described by Voretzsch (*O.Z.*, Jahrg. 3, Parts 1–4, Fig. 12). So long as only unsatisfactory photographs are available, these must be passed over in favour of specimens permitting verification in Europe.

Stucco appears to have been preferred in the sculpture of Prapatom. A torso of this material (Plate 7) with raised right hand (this part, alas! mistakenly restored) has already been reproduced (Voretzsch, Fig. 11). That it depicts the attendant figures of a Buddha is proved by the lifted hand, which, as in the Bodhisattvas, holds the handle of the fly-whisk in the gracefully curved fingers. The other rests on the hip, over the simple loin-cloth, unfolded on one side only. A patch of ornament accentuates the middle of the apron, a chain is hung about the neck. The body, which, contrary to Indian practice, is otherwise unclothed, has a scarcely noticeable twist in the slender hips; the tenderness of modelling far exceeds the most pronounced examples of refined delicacy in Lower India. As in Central Java, the bodily structure has laid aside the last vestige of Gupta formalism. The Malay type shows a more free, dancing quality of movement, surrendering itself with greater abandon to the play of the limbs.

Prapatom makes us acquainted with the earliest form of art practised on Siamese soil, and puts the Malay kingdom at the head of that series of factors which, in the course of centuries, in never-ceasing interaction, produced works of art in the valley of the Menam. Contemporaneously, these early efforts show what stage of attainment had preceded the great monuments of Java. The political solidarity of Java, Borneo, Sumatra and Siam inferred by Coedès ("Le Royaume de Çrivijaya," *B.É.F.E.O.* 18, 6) and Ferrand (*L'Empire sumatranais de Çrivijaya*, Paris, 1922) becomes an artistic and geographical unity by virtue of the Prapatom discoveries. The existence of this long unknown empire was disclosed by Arab and Chinese reports. Finally the discovery of two Sanskrit inscriptions afforded secure data. The earliest (dated A.D. 686) was found in the island of Banka, on the south-east coast of Sumatra; the second, of 775, in Vien Sa, on the south coast of the Malay Peninsula. Another is the Mid-Java inscription of the Kalasan of 778. The nucleus of the Malay kingdom of Çrivijaya was Sumatra, the capital probably Palembang; Java up to the 9th century remained under the overlordship of these kings of the House of Çailendra. The art of Mid-Java must therefore be regarded as manifesting the influence of the great Malay Empire, as likewise do the primitive monuments of the mainland. Chronologically, this complex must be confined within the 7th to 9th centuries; after that each district lives its own life, and Java goes a different way from Siam.

The high civilisation of Sumatra, the ancient land of gold, is attested by the Chinese pilgrim, Yi tsing (end of the 7th century), who commends the attention paid

to Sanskrit studies and the interpretation of texts (Ferrand, *ibid.*, p. 160). The empire owes its culture to the Hindu immigration, which facilitated the acquisition of the neighbouring lands. This Hinduising is one of the outstanding facts of Asiatic history (A. Foucher, *L'Art gréco-bouddhique du Gandhara*, Vol. II, fasc. 2, Paris, 1922) : " This Indianisation of Lower Asia, largely unknown in Europe, is none the less in the general history of the Old World a fact scarcely less important than the Hellenisation, so constantly referred to, of Hither Asia "). On the ruling Island the relics of its great past are still lacking, and the mainland must supply the want.

The sculpture of Malaya is contemporary with the Gupta period in India, the Wei and T'ang periods in China. It is the handmaid of Buddhism ; at any rate, none of the monuments so far discovered in the south of the Peninsula can be referred to the Brahmanical cult with any probability. This art remained free from Graeco-Buddhist influences ; indeed it was impossible that Gandhara could exert influence in such far distant lands. It had inspired the powers of the Buddhist artists, but the Malay kingdom of Çrivijaya was in essentials governed by its own possibilities ; consequently Further India cannot be looked upon in reference to art as a province of Western Asia. The graceful delicacy of line, the facile elegance of arrangement in flat specimens, the lively rhythm of the modelling, are distinct from the Indian type.

To the latest era of Malay art in South Siam belongs certain bronzes (Coedès, *Bronzes Khmers*, Paris, 1923, Plate 27 ; and Voretzsch, *ibid.*, Fig. 17) which stand by themselves. To this group must be assigned the bronze torso from Nakhon Sawan (Plate 8). The place of discovery lies in Central Siam, near the confluence of the Meping and Mejai rivers. Thus the southern type of art has also penetrated into a district that lay on the circumference of the Malay country proper. The ornamentation on the loin-cloth and the upper arm make clear that it is a Bodhisattva. The decoration is still comparatively scanty. The torso of bronze is not inferior in mobility to those in stucco from Prapatom. The similarity with the later style of the Borobudur is so striking as to justify its reference to a similar date, the 9th and 10th centuries.

The instinctive certainty with which the Malay peoples originated an art bears witness to the creative vigour of the race. It embraced during its most flourishing period a vast area of population. Later the Malay country was confined to narrower limits. From the 10th century onwards Upper India is more and more lost to it as the empire of the Çailendra falls into decay. From the 11th century its artistic development is limited to Java, and eventually to Bali.

CHAPTER IV
SAWANKOLOK

The Indian colonial civilisation in the south of the Siamese peninsula affords us the earliest example of the development of plastic art. At the opposite pole, north of the river valley, the twin cities of Sawankolok (" Sangha-Land "), on the Menam Yom, and Sukothai (" Dayspring of Good Fortune ") exert an influence at some distance from the sea. Both serve as capitals of an empire to which Sukothai has given its name. The great migration, that makes the fortunes of Siam full of changes for a thousand years, must be dated as early as the first centuries of our era. Only after the 14th century can we count on stable racial conditions. The decisive factor is the irruption of Mongolian peoples from the Tibetan highlands. Their presence in Sawankolok and Sukothai is substantiated from Chinese sources as early as the 7th century A.D. (P. Lefèvre-Pontalis, *L'Invasion Thaie en Indo-Chine*, Part 2, T'oung Pao, 1909, p. 7). It may be that prior to their leaving their first home this lay still more to the north-east of the continent. They were connected with the Laos-Thai family of peoples, boasting originally no doubt only a low degree of civilisation. The anthropological characteristics of the earliest immigrant races are not so far determined, since Science has not hitherto availed itself of monumental evidence to discover their precise habitat. These peoples derive their first civilising discipline from contact with the Indian colonies and the Malays of the south. An inscription expressly mentions immigration from Ligor (*B.C.A.I.*, 1909, p. 202), at a later date it is true. Colonisation, however, by Indian settlers overland would also be possible, though less probable. Politically, from the 7th and 8th centuries the Thai fall more or less under the sway of their neighbours to the eastward. Sawankolok, in the north, forms the central point of this influence. Subjugation by Cambodia follows as early as the 7th century (cf. Lefèvre-Pontalis, *ibid.*). The inscriptions employ the Cambodian language. A highly artistic people, the Khmer, had already at the very beginning of the century produced an architecture of their own in Cambodia. This is attested by monuments such as the Temple cell at Hanchei (G. Groslier, *Recherches sur les Cambodgiens*, Paris, 1921, p. 209). To begin with, Brahmanism and Buddhism hold the same position in Sawankolok as in Cambodia. But sculptures of early date discovered in the twin towns lead to the supposition that these very soon became a centre for the dissemination of Buddhism, and thus from Siam an influence reinforcing the cult of Buddha spread to the eastward. Whether it was the original Little Vehicle or the wide scheme of the Great Vehicle that was concerned, the evidence of the monuments does not enable us to decide. Both branches in fact existed side by side. Differences of an iconographic and artistic kind must not be over-stressed, as Foucher (*L'Art graeco-bouddhique*, Vol. II, fasc. 1, p. 386) has already pointed out. In Cambodia, at all events, the Mahayana gained preponderance. The Mon-Khmer settled there are clearly distinguished from the Laos-Thai. In particular they exhibit less of the Mongolian type and show themselves at once by their lighter colouring to be the close kin of the Aryan race. An infiltration of foreign blood is assumed. These

13

same Khmer peoples long dominated the centre of the Peninsula in matters of civilisation; but no actual specimens of their art, above all no bronzes, have survived which are anterior to the classic style of the Angkor period (9th to 12th centuries). The fact that in Sawankolok and Sukothai a sculpture more nearly akin to the Gupta is to be found must not be interpreted as being of merely local significance; it goes a long way towards proving that in early times Cambodia also passed through a similar phase. At the same time the fusion between the native Thai and the rapidly expanding Khmer no doubt progressed very fast.

The sculpture of the Khmer must have gone through a stage similar to that of Sawankolok—a stage, however, that cannot so far be verified.

FIRST THAI STYLE

The finds here assigned to the 8th and 9th centuries are distinguished from the Khmer bronzes chiefly by the material. They do not exhibit the blackish " Samrit " alloy which gives a dark green patina. On the contrary, the earthen nucleus is covered with a thick bright emerald-green layer, which points to an earlier origin, and the outside surface has generally suffered greatly.

The torso of a standing Buddha (Plate 9) is distinguished from the Lower Indian examples by the unusually bold treatment of the drapery, which stands out from the body-like wings. The fold extending from the hand, half-way down the leg, is clearly marked on either side. The piece of drapery between the legs is given sculptural prominence; in Lower India it is only the body which is given a forward thrust. There again it has not this sturdy bulkiness. For all that, the modelling of the leg and the fold has the effect of a free fantasia on a Gupta motif. The attitude of the two hands—Vyakhyana (Exposition) mudra, displaying in the palm the symbolic wheel of the cult—belongs to the primitive types.

The figure of the Buddha (Plate 10), sitting with crossed legs (in padmasana), is in comparatively good preservation. The attitude of the right hand signifies the challenge to the earth to attest his mission (Bhumi sparça mudra), the gesture wherewith Buddha vanquished Mara the Wicked One. The drapery leaves the right breast bare, and one corner hangs down over the left. In the softness and fullness of the irregular features the designer, inaugurating a new departure in art, comes nearer Nature than in any known Khmer bronzes.

More distinctive is the detached head (Plate II) with its curiously ovoid form. Boldly modelled locks are carried up to the top of the cranium (*ushnisha*) and descend to the middle of the forehead. The eyebrows spring in the form of slightly raised crescents from the root of the nose. The nose itself is rather hooked. The mouth, which almost invariably shows full, chiselled lips in Siam, lifts the corner in an almost imperceptible smile. The Indian prototype is to be found in Sewell (" Some Indian Bronzes and Reliefs of Buddha," *J.R.A.S.*, 1895, Plates 1 and 2) and Coomaraswamy (*ibid.*, Plate 21). The little knob over

the root of the nose (*urna*), elsewhere indispensable, the sculptural rendering of the tuft of hair prescribed by the canon of beauty, are absent in the earliest as in all later Thai heads.

The Gupta tradition allowed but little freedom to the Siamese sculptor, and he adopted it only to lose it again very soon. This is at once indicated by another head of the same period (Plate 12 A), in which eyes and eyebrows are encircled by the conventional play of the contour lines. It is as if originality froze under the hands of the sculptor. In the case of the earliest productions modifications are not lacking. True, it so happens we have hardly anything available but heads of Buddha, but these give the whole scheme of the figure, for the head of the Honoured One is the seat of all expression, the central point of the composition. In many instances the locks are somewhat more lightly indicated (Plate 12 B and Plate 13 A), while the skull is given more roundness and delicacy. Of all examples this shows the smallest sign of racial characteristics; rather is it an impressive embodiment of all the essential qualities of Buddhism. The mask of the Redeemed in this Siamese example exhibits the same expression of repose we see in China of the T'ang period. It is equally prevalent in Cambodia. But there the human types (for these cf. Groslier, *ibid. passim*) are different. The countenance is more broadly moulded, the nose is straight, the chin hardly defined. The eyebrows often emphasise the horizontal line rather than the arch, and join together to form a transverse bar. The hair always meets the forehead in a straight line. The same conventional scheme is followed in the Gandhara face; there again the arch of the eyebrows was reduced to a fine line. At the same time there is inherent in every detail a naturalistic feeling that has never touched the east of India. This is of no avail as a stimulus, for there a totally different sentiment towards Nature was operative.

SECOND STYLE

The examples cited above have shown the derivation, in relation to model and type, holds good for all Upper India, from the Gupta tradition before the completion of the first thousand years; but the further development in Northern Siam points to a growing independence. Descending from the northern highlands, there come ever more men of the races to which a happy fate had destined the whole of the fertile lands on the Menam. Possibly Art might supply authentic information about racial variations and modifications, had we anything more for reference than mere chance finds.

A sudden infusion of Khmer blood manifests itself in a small fragment (Plate 15 A) which, in contrast with the examples so far dealt with, comes not from Sukothai, but from Sawankolok. Its disintegrated outer surface forms a miracle of variegated patina. The composition of the bronze is darker in hue, and now not very different from the "Samrit." The brows are delicately arched, all transitions of plane are imbedded beneath the surface of the skin. Sawankolok, then, has not succeeded invariably in asserting the artistic independence of its rulers. The

delicacy of modelling and breadth of expression lift this Khmer-like head out of the group, which is by no means always of a correspondingly high quality.

The Second Style (end of the 10th and beginning of the 11th century) shows only in very exceptional cases the slightest trace of foreign influence. And it is just this first outburst of independent, local inspiration that gives this style its significance. Looked at from this point of view, the gilded head from Sukothai (Plate 14 and Plate 13 B) is one of the greatest masterpieces of Siam. The stamp of the Thai race proclaims itself unmistakably. The nose is hooked, the lips are thin, the eyes show the Mongolian opening, the chin is pointed, the hair brought down to the middle of the forehead—trivial modifications of the Buddha face known in India, with its spacious modelling and its heavy, straight locks. But the smile has no longer a universal appeal, it speaks only to the people from which it was directly taken. Despite certain traditional elements its creator has displayed the most original invention in this bronze. He recalled the Indian rule and standard, only to frame for himself a new law out of them. No doubt Angkor, the Khmer capital, was still to remain dominant, but this can be true only politically. Such then must have been the situation in the 10th and 11th centuries in the empire of Sawankolok and Sukothai.

The Thai head of Indian genesis remains a factor in the history of Art. Frequently the boldness of individual execution is surprising (Plate 15 B and Plate 16 B). Still more clearly do particular characteristics stand out, the curve of the eye, the repetition of the eyebrows in the extremity of the hair-growth and in the fold of the mouth, the hook of the powerful nose, the pointing of the ears. Confronted with this head one all but forgets its purport—to be an image of sanctified abstraction from reality.

Moreover, the trunk is framed in a fashion definitely new (Plate 17). The stiffness of the lateral folds is carried over to the girdle and the part of the drapery between the thighs. In place of the etherial delicacy of Khmer modelling is an uncompromising configuration of vertical and horizontal lines. Thus does the young, vigorous race revolt against artistic forms of a higher civilisation. The plain chain draping the neck makes it likely that this figure of cast metal belonged to a Bodhisattva.

In Art, as in History, there are periods of reaction. A head corroded by a dark green patina (Plate 16 A) affords the example of a Near Western influence. At once the wide mouth with upturned corners has a foreign look. The high border-line of the coiffure and brows is found in no other monument of the period. The massive breadth of the face, again, is foreign to the Thai. Another clear indication is the modification of the *ushnisha* into a sort of helmet spike. This points to Burma, where " a national and individual fancy " (Foucher) was responsible for this crown-like arrangement of the hair. For choice this took advantage of the canonical outward bulge of the skull, as was noted by Foucher (*ibid.*, Vol. II, fasc. 2, p. 688). A similar selection of shape had already produced the crowning member of the Burmese pagodas. Which Burmese stock influenced the Thai city, or perhaps sent thither

its sculptor and his handiwork, cannot be determined. Very possibly we may fix upon the Talaing, roughly speaking particularly near neighbours, whose distinctive art has not yet been investigated. In any case the 11th and 12th centuries mark the highest point in the political ascendancy of Burma, and consequently examples of its influence must be assigned to this period. The evidence of artistic connection gains enhanced significance when we consider the religious relations. From Burma comes an increased vogue of the Hinayana, a form of religion bound to accentuate yet further the contrast in political importance between the Thai and the Khmer, devoted as the latter were to the Mahayana (cf. E. Grousset, *Histoire de l'Asie*, Paris, 1922, Vol. II, p. 304).

Artistically, the first Siamese Empire remained in communication with the East without abrogating its individuality. It is only thus that we can account for a stone head from Sukothai (Plate 18). The heavily moulded coiffure, the sober arrangement of the mass of hair in two coils, is still in the tradition of the first style. The delineation of the eyebrows points to the mature art of the Khmer country. Mutilations and disintegration obscure the details of the face. All we have left is a magnificent ruin, out of which light and shade can conjure the magic of an ineffable beauty. Where mouth and eye can be surmised, a deep sense of mystery plays over those features akin to the dreamy sweetness of Cambodia. Cross currents of possible evolution meet and unite in fresh combinations, to lay the foundation of a noble sculptural wealth of form.

CHIENG-MAI

Again, the twin cities (Sawankolok and Sukothai), which transformed so many alien accretions, were in their turn a centre of influence. Evidently the Thai must have looked back on the way they had come. In the highlands they had left behind them their gate of exit: Chieng-mai, in the north-east of the river country. Only at a much later date does the brother nation of the Laos push on into this region.

A Buddha (Plate 19) from Chieng-mai may belong to the 8th or 9th century. It is only further south, in the Malay sphere, that the European sitting-posture need be taken as indication of a late date. Apparently the two hands show the gesture of exposition, characteristic of the early period. The treatment of head and trunk corresponds in details—modelling of the face, mouth and arch of the eyebrows—with the Khmer examples, but the execution is crude and provincial. On the pedestal appears an ancient motif, two demon heads treated decoratively, such as are constantly found in Ceylon and Amaravati (cf. V. A. Smith, *A History of Fine Art in India and Ceylon*, Oxford, 1911, Plate 22). Judging from the limited material at our disposal, this peculiarity is entirely contrary to what is usual in Siam.

CHAPTER V
LOPBURI

On the Middle Menam, at latest in the 9th century, a new centre arises: Lopburi ("The New Town"), favourably situated at the point where the roads from the east reach the river. Cambodia at the zenith of its domination was able to exercise almost unlimited power over the district. But when the Khmer were building in the western part of their empire, the work was carried out with more freedom than in their own country, and with architectural peculiarities we meet with nowhere else (*B.C.A.I.*, 1909, p. 197).

These provincials made bold to follow their own inventive genius. Moreover, an impulse was often given by prisoners of war which still further augmented the combinations and influences developed in so many directions. As in Northern Siam, the inscriptions were written in the Khmer language. Petithuguenin calls Lopburi "the Khmer capital in the Siamese country" (*Journal of the Siam Society*, Vol. II, "À propos des origines et de l'histoire ancienne de Siam"). In the neighbourhood of Chantabun, on the east coast of the country, a tablet was found belonging to the end of the 10th century (Aymonnier, *Le Cambodge*, Vol. II, p. 80). Gerini reports stone documents dated A.D. 1023 and 1025 (*Kingdom of Siam*, p. 223).

Like all peoples of Upper India, the Mon-Khmer took their point of departure from the Gupta sculpture. But their modelling of the human form was lighter than that of India, without thereby attaining the mobility of the Malays. Theirs was the spirit that inspired the Bronze of Plate 20. In contrast to Plate 2, the trunk is left naked to the waist, a mode also favoured by the Malays as well as in Cambodia. Parts of the drapery, the girdle broadening in the centre, the medial fold stretching downwards, are touched by the general rhythm of the contour. All curves flow easily into one another. Even an eye accustomed to the naturalistic representation of the body in Greek art, cannot remain blind to the perfection of the modelling, the sure realisation of a feeling for form.

To the beginning of the period belongs the noble slate head of a Buddha (Plates 21 and 22). As yet the heavy locks are not set back from the brow, nor drawn down as with the Thai. In spite of mutilation one can surmise the straight nose. The eyebrows merge delicately into the root of the nose and show the eastern type of line. The eye is a double curve imbedded in the surface. The full lips are marked off from the smooth flesh by a contour line. The chin terminates broadly. No linear markings indent the rounded visage. Only the pupil is heavily incised. This is not the way to convey the impression of a seeing eye. Eyes of this sort make the general expression cruder than we are wont to see in the usually suave and seldom individualistic Cambodia. In a word, all sculptural forms are wrought on a bolder scale than any produced by the eastern neighbours of Siam. Was the Khmer artist in this case free from fetters of conventional rules, or was it the Thai blood that the impulse came from?

This first type can be referred to any fixed pattern only to a small degree. In a rather later Buddha head (Plate 23) the hair is confined in smaller masses, so that

19

it stands back from the brow without any surrounding border. This sculptural application of shadow remains confined to Siam. The continuous line of the eyebrows, with only a dip in the middle of the unbroken double arch, is borrowed again from Cambodia. The pupils of the eyes were incised without the delicacy of the Khmer technique. These heads still derive from Angkor, and in any case are peculiarly the work of a frontier land, for that very reason not weaker but stronger, enriched in significance and expressiveness.

Strange combinations are blended when clay is the material used. In Prapatom, that is to say, within the range of influence of Lopburi and its Khmer rulers, we find a votive tablet representing Buddha sitting in an attitude of Meditation (Yogasana) beneath the Tree of Knowledge (Plate 24 A), clad in the clinging drapery of the Gupta, with the features and coiffure of the Khmer. The carriage of the hands under the tree is the same as when guarding the Snake-god, that of Contemplation (Dhyana-mudra). In Cambodia this posture was shown with the upper half of the body naked (With, *Asiatische Monumentalplastik*, Berlin N.D., Fig. 6). A comparatively early origin, somewhere in the 9th or 10th century, is indicated by the sparing leaf ornament of the background. Naturally the possibility of mechanical reproduction gave wide dissemination to this type.

Another piece resembling the one considered above comes from Nakhon Racha Sima, lying in the uplands eastward of Lopburi (Plate 24 B). The carriage of the hands is still recognisable in the three Buddhas (Dhyana-mudra in the attendants, Bhumisparça-mudra in the principal figure). The architecture of the pagoda in the centre is entirely borrowed from Cambodia. The opening is framed by an arch, the acroteria (angles of the pediment) of which turn the simplified naga-head to one side. The graceful swing of the figure, no less than the head-dress, is precisely the same as in Khmer bronzes (cf. *Arts et Archéologie Khmers*, Year I, fasc. 2, Plate 14). It is in clay that the reaction of the native race against the Eastern conquerors asserts itself. The commencement of the growing Thai ascendancy, somewhere in the 12th century, must be taken as the date of certain stucco heads. The technique is recognisable as being of the Prapatom period. This persists in Siam, and is very seldom met with in the east of Upper India (cf. *B.C.A.I.*, 1909, p. 197). Perhaps, by reason of the pliability of the material, it gives the Thai artist the best possibilities of working out his effects.

A head (Plate 26 A) reproduces the heavy locks in stucco in an unusual way. They look as though engraved, and are reduced to a pitch of mechanical regularity which enables us to surmise not only the predilections but also the ultimate fate of Thai art. Siamese peculiarities are not lacking—the slight depression on the middle of the forehead, the curve of the eyebrows, which are kept apart. These lines, like the eyes, are incised with a bold touch. Probably the nose, now damaged, was hooked. From the nostrils a fold descends to the deep corners of an ordinary full mouth. It gives structure to the mass of flesh. Texture is clearly indicated in the rounded contours, and they do not fade away into each other, as in Cambodia. We can trace how the centuries vary to some slight extent the original

20

conception (Plate 36 B), how the hair knots grow smaller, the depression of the brow more clearly marked, the composition of the lines more conventional.

More personal is the appeal of a little stucco head of white, finely kneaded clay (Plate 25 A), which still bears traces of gilding on a black slip. A fillet confines the curls, a mere cluster of smooth knobs; but the central depression in the forehead is indicated. The nose has the Semitic hook, the lips a negro-like fullness. A similar type was later on followed by the Laos peoples in their modelling of the face. Were the makers of the stucco heads specially near akin to this branch of the race? Their work in Lopburi possesses the boldness and largeness of a first essay and seems derived from the vital power of a hard-fighting people. Even in the borderlands eastward of Lopburi, in Nakhon Racha Sima, men learned to be independent of the Khmer influence (Plate 25 B). Within the oval—resembling the impression of a seal—of the composition are grouped round the central Buddha eight configurations with flower tendrils and miniature pagodas as background. For Buddha the Dharma-çakra-mudra (the motion of turning the Wheel of the Law) was chosen. The background of the figure no longer recalls architecture and is finished off with a border of tiny flames. The vivacious movement of the dainty limbs shows a tendency towards a decorative treatment which, like the crowding of the composition, recalls the terribly over-decorated products of later days. This complete break up of the general rhythm into innumerable details points the way to the unhappy future of Thai art. The clay tablet cannot have originated before the 13th or 14th century.

Side by side with the national reaction shown by the stucco monuments, the Khmer type prevailed for centuries in Lopburi. Its representatives are also not infrequently met with after the quickening of the native element has taken place. It may be the lips were made a trifle more pouting (Plate 27 A). But conscious variations of feeling, barely recognisable as yet, afford less ground for the determination of locality than does the rude, provincial workmanship (Plate 28). Cambodia modelled the mouth in particular with greater care, the deeply incised corners are far removed from the classical formula. Several heads from Lopburi (Plate 27 B) are in fact neither more nor less than Khmer monuments on Siamese soil. Every special peculiarity seems obliterated. The ornamental fillet round the hair might well point to a Bodhisattva, while the remaining examples show the Buddha's coiffure with a roll set back from the brow and arranged according to the mode customary in Angkor. While the individuality of the immigrant peoples that entered Siam from the north was growing more pronounced, in the stone sculpture of Lopburi it fell completely into abeyance from the 10th to the 13th centuries.

Another head in bronze (Plate 29 B) gives evidence of dependence on the East. This interesting piece is probably the head which Fournereau found (cf. Fournereau, *ibid.*, p. 135) in the neighbourhood of Ratburi, and therefore in Southern Siam, that is, to the south of Prapatom. The conventional, niggling treatment of the hair makes its origin before the 12th century improbable. The Malays even had been affected by Khmer influence. It was the irruption from the north by successive stages that first modifies the predominance of the foreigner in Art. The change of

style to be noticed in single bronzes cannot be assigned to a date earlier than the end of the 12th century (Plate 29 A and Plate 30 A and B). A remnant of the old free practice is still to be seen in certain details. Much evidently belongs to the Thai— the arched eyebrows developed from the semicircle, the deep insertion of the nose, the *ushnisha* development of the first examples (to be considered later on), the pointed, bulging ear of the second. However, these Thai forms, imported ready-made, denote a later style, an elaborated, formal conventionality. Everywhere hard edges stand out. These latest bronzes are dominated by a striving after clearly marked articulation, which owed its origin elsewhere. Geographical considerations have made necessary this passing reference to the sculpture of Lopburi. The subject will be treated more fully in later chapters.

CHAPTER VI

PITSANULOK

The systematic co-ordination of material geographically can be made to tally with the course of artistic evolution only to a small extent. It forces us to hark back from time to time. More complicated even than in the south is the sifting of styles in the north. South-eastwards of Sukothai, on the banks of the Menam Jai, arose a centre which, despite the nearness of the ancient capital, followed its own way. Fournereau identifies the name with Vishnulok—Land of Vishnu.

FIRST STYLE

The commencement of artistic creation here must be sought for about the year 1000, and a head of red finely kneaded clay (Plate 31 A) may be cited in evidence. It comes surprisingly near to the monuments in the same material in Lopburi. Laos elements, such as the hooked nose, the distortion round the mouth, the pointed chin, are if anything exaggerated. From Sukothai came the heavy, straight spirals of the hair. The eyebrows and the extremities of the hair are still rendered entirely by undercutting without the use of lines. Here we see at work a sculpturally independent branch of the Laos-Thai stock, which naturally was mainly indebted to the more ancient Sukothai for its artistic achievements. An example in white stucco (Plate 31 B), undoubtedly Siamese, defies determination of its original source. The linear treatment of eyes and adjacent parts is reminiscent of Lopburi. The chin bears more resemblance to the Northern Siamese school. The Burmese head-dress should be an indication leading us to assign it to the Pitsanulok district. It reproduces—recognisable in spite of mutilation—the Burmese pagoda shape. It is probable that this offshoot of Western art was able to maintain itself, not in the sphere of Cambodia, but in the north, where relations may be surmised more readily.

The most insoluble riddle in Siam is offered by a small stone head (Plate 32 A). Had not the place of discovery been explicitly given by Voretzsch, an attribution to the Cham art of the 8th to 10th centuries would admit of no doubt. The conception is not Buddhistic. The naga umbrella, still recognisable, sheltered a Vishnu. This is shown by the head-dress, taking the form of a crown of leaves, and the ear ornament. The broad brow, the rounded modelling of the details of the countenance, unfortunately much disintegrated, speak in unmistakable terms. The flattened chin, the straight mouth, the shape of the face developed from the rectangle, the heavy animal expression, originated with the Cham race. The most striking proof is afforded by ear and head ornaments. The rows of graduated rings Parmentier characterises as typical of Champa (*Les sculptures chames au musée de Tourane*, Paris, 1922, Fig. 10). They appear also in Cambodia in a more detailed form. On the east coast of Upper India representations of " The Enlightened " are only found rarely. So highly decorated a head could there, and this is equally true of Siam, be connected only with Vishnuism; but it must be remembered that among the Thai Brahmanism never ceased to exist alongside of Buddhism. It is note-

23

worthy that the first Brahmanical movement of the early period belongs to a locality which, as its name implies, must, at any rate in the beginning, have been acquainted with the Brahmanic cult. Whether this small sculpture could have come in from elsewhere, originating with refugees or prisoners, the obscurity of the relations between Siam and Champa makes it impossible to conjecture. It is surprising that vase forms which Cambodia never knew, and which are proved in Champa, occur also in Siam (*B.C.A.I.*, 1912, p. 32). It is plain that the racial kinship between Thai and Cham, between peoples coming from a common northern cradle, must be held responsible for these surprising relations.

The same bold modelling as in the stucco head is found also in bronze (Plate 33). The surface of this piece belongs by virtue of the patina of the gilding to the finest of the examples. In place of the broad treatment of the hair are now found rows of little knobs or balls of conventional pattern, bordered by a small encircling fillet. Nose and eyelids remain embedded in the surface, otherwise heavily traced curves mark out the features. Here we find the classic type of the Thai style—not stifled by routine, but bold, serious, austere, possessing the marks hitherto considered Siamese. Only this first beginning links the early delicate style of Sawankolok-Sukothai in Pitsanulok, preserving the living enthusiasm that emanated from Cambodia and the earnestness created in the last resort by Gupta sculpture.

The form of a praying disciple (Plate 32 B) at once reveals the cooling of the direct artistic inspiration (cf. P. A. Thompson, *Lotus Land*, London, 1906, p. 100). The folded hands are still attached to well-rounded arms. Details of the head closely resemble the last example. The flying skirts of the drapery held to one side and the workmanship of the folds are the most highly accentuated features.

The trunk of the early Buddhas from Pitsanulok shows even more bulkiness than in the Sawankolok era (Plate 34). It rests on a pedestal, the simplicity of which is lost later on. The fleshy arms, the strong body, the massive build, correspond with the structure of the head in Plate 33. Pleasure in the play of line complicates the hitherto simple folds of the robe and doubles its contour to form the bottom of the drapery in front of the ankles.

A torso dating from the beginning of the period preserves the back view (Plate 35). Here, again, all articulation of the drapery clings closely and smoothly to the body. The contour alone differentiates the clothing from the bare right shoulder. As in the front view, one corner falls on the left side, but simply as a plain strip without fold or pleat.

SECOND STYLE

The establishment of the classical type marks the 12th century. Often a fillet emphasises the meagre modelling of the hair (Plate 36 A), running parallel with the lower boundary line of the forehead. In the sculptural treatment of eye and mouth the effect in this example is particularly feeble, without belying the peculiarities of the borrowed classicism. All the features are marked out by encircling lines. Lastly here, too, we see the national mode of representing the hair as terminating

in a flame, a development that belongs only to Siam and implies a decorative enhancement of the Buddha figure.

A like motive is displayed by a head (Plate 36 B), the elongated oval of which comes near to the Sukothai type. Evidently racial variations, even at a time of creative poverty, in the 12th and 13th centuries, have their influence none the less on the composition. Nor is there ever lacking in the determination of the artistic process some influx of foreign blood, which, however, no longer interrupts the continuity of development.

A contrary example to the foregoing illustrations is offered by another head found in the same locality (Plate 37 A). There can be no more striking evidence of racial interchange in the sculptural types. Hair and forehead are Thai; the three-tiered head-dress derives from a strange, fantastic imitation of plant life. Brow and mouth come from Cambodia. Purely original are the wide-opened eyes and flat nose. The width of the face is unusual in Siam. Unless we choose to hold a sculptor's fancy rather than any racial influence responsible, its origin must be sought in Nepaul, or even in a Negrito stock. Negrito elements in Upper India are constantly alluded to by anthropologists. In any case the pointed locks indicate a late date, at which all free invention of new forms had been forced into abeyance, while it was possible, none the less, for a racial peculiarity of countenance to manifest itself.

From the divers variations emerges, from the 13th century onwards, a fixed Pitsanulok type. A conventionalised modification of Sawankolok form is often surmounted, without any hair fillet, by the crowning flame, soon to become an indispensable feature (Plate 37 B). The heavy locks end in points, the central structure is squeezed together into lines within a narrow area in the centre of the broad face. The ears are no longer, as before, fully developed elements of the composition, but are rather added on as flat outstanding disks. The sculptural type more and more renounces details and modulations, finesse and expression, to indicate with greater clearness than ever the facts of racial affinity.

The trunk, too, is involved in the conventionalising process (Plate 38). This torso is of particular interest technically. The earthen nucleus is first covered with a casting of bronze (visible on the right leg), which again supports a second, forming the actual surface—a double casting therefore, a laborious and painstaking procedure. The ornamentation seems to indicate a Bodhisattva. The girdle round the naked body tapers upwards. Details are less rich but more defined than in the Malay torso (Plate 8). The pose is usually frontal, very different from the mobility in Prapatom examples. The flesh with its smooth modelling is strongly contrasted with the drapery, which is frequently rough. The craving for curved lines breaks out with elemental force; even the pedestal is instinct with it (Plate 39). The fingers are thus in the Bhumisparça attitude, the head-flame is articulated, the contour of the ear is curved and the nose and lips are formed by it. The last vestige of the Gupta-Khmer tradition seems exhausted and worked out. We might well assign this heavily moulded, strongly accentuated piece to the commencement of mechanical reproduction in the course of the 13th and 14th centuries.

25

Subsequent to the last Siamese phase there were trifling variations, it is true; but a judgment as to age and value can only be framed on consideration of material and sculptural qualities. A head in the Musée Guimet in Paris (Plate 40) possesses the small hair knots, the linear framework of the face, and bevels off the edges of the contours against the mass. Brows and nose make one uniform structure, carried sideways and forwards. The hair fillet is not present. A new feature is a conspicuous incising of the pupil, giving life to the eye. This last naturalistic attempt the Thai artists had carried to the furthest extent (Plates 41 and 42). They formed the eyeball of iridescent mussel shell, the iris of black, shiny stone. The Cologne head, whose incomparable patina cannot be suspected from the photograph, marks, therefore, the final and definite reduction to formulæ of the mature art of Pitsanulok. There is a curious contrast between the naturalistic eye, the delicately modelled rotundity of the flesh, and the firm, close rhythm of the sharply accentuated lines, which in ear, brows, hair, nose, mouth and chin belie every reminiscence of the natural proportions of those features. It is the twofold character of the impression produced by it which constitutes the enigmatic magic of these heads. They seem modelled on actual reality, and at the very same time carried back to an attitude they can never abandon of obedience to conventional laws. By this time the endless reproduction was possible which was wanted. The more sculpture donors presented, the more merit they accumulated for themselves. The total output must have been enormous; for the late period of Pitsanulok art examples exist in very large numbers, whose sculptural value, however, is altogether uneven.

There are variants (Plate 43). A thin ridge marks off the hair. The inlaid eye is absent, but appears to have been present originally. The ear is sharply pointed, caught in the general rhythm. The skull flame is also missing. The fullness of the figure is independent of the general proportions, the distinct co-ordination of the sculptural means loses in directness. In this monument, a work of the highest simplicity, is concentrated the Buddhistic ideal of quietness and abstraction from the world, in a Siamese setting. The example in the Musée Guimet (Plate 44) precedes the decadence. Already the corners of the mouth are incised as though with a graving tool. The delicate gradation of the lines against the flesh is gone. Thus Sculpture becomes a document which evinces an artistic volition without the power completely to exploit its plastic possibilities. There are, in fact, always and everywhere distinctions of quality. These consist not in a greater or lesser degree of technical skill—in Siam this tends to increase rather than diminish —nor in a greater or lesser truth to Nature. The most significant work of art is that which most nearly corresponds to the conditions recognised as typical for a place, a time, a race.

Regarded from this point of view, the fragment of a bronze mask (Plate 45) forms a last outstanding example. The destruction of the earthen nucleus is no doubt mainly responsible for the fragmentary condition. A mere vestige of the inlay is preserved in the eye. The richly ornamented crown notwithstanding, it is not certain that a Bodhisattva is here represented. Iconographically, too, the

Thai people makes itself felt. It carries the plain, unadorned Monk Gautama into his proud and happy world of victory, and fashions the type of " The Enlightened " in regal splendour of decoration. This is found also in Cambodia ; but it acquired in Siam, more especially in later times, so universal a vogue that we may infer a reaction affecting Cambodia ; still, the Eastern examples belong to a comparatively late era, and can be cited only under the representative form beneath the naga umbrella (cf. Coedès, *Bronzes Khmèrs*, Paris, 1923, Plate 22, etc.). A Pali text of later date, the Jambupatisutra, gives the iconographic significance in full detail (cf. Finot, *B.E.F.E.O.*, 17). In this narrative the Master chose the form of the King of Kings in order to convert the proud monarch Jambupati. Coedès sees in the figure the Buddha " less from the human and historical aspect, far more as the manifestation of the absolute, as the supreme god of the adepts of the Mahayana " (Coedès, *ibid.*, p. 36). Inasmuch as the Pitsanulok sculpture, as indeed all North Siamese monuments after Sawankolok, belongs to the Hinayana and the form adopted from the Jambupatisutra constantly appears, this fact shows that the iconographic choice was determined rather by national needs than by reasons of religious motive. The prevalence of the decorated Buddha makes identification of a torso or a head in Siamese Pali-Buddhism an impossibility. The border line between " The Enlightened Ones " (Buddhas) and Bodhisattvas is lost in vagueness.

Again, the thematic significance of the torso in Plate 46 remains doubtful. The contour lines of the faces are transferred to the trunk, and they frame the arm like an ear, fashion the flying garment into wings and confine the legs together underneath. The Thai rhythm shows most clearly in the hands (Plate 47). It bends the tips of the fingers outwards and clenches the whole hand into an almost mechanically constricted shape. This hand exhibits a special peculiarity of the Hinayana. The thirty-two criteria of beauty (*lakshanas*) vary. The older school counts amongst them the equal length of the fingers (cf. Foucher, *ibid.*, p. 312), which is realised almost completely here. The Mahayana, as a rule, disavows this fastidious limitation.

Though a southern origin is possible, we will speak here of a bronze forming part of the Treasure at Bangkok (Plate 48). The countenance corresponds in all particulars with a very hard Pitsanulok Buddha. A surprising effect is exercised by the archaic carriage of the hands, both raised in the Vyakhayana-mudra, raising the symbol of the wheel. On the neck the ornament is sparsely distributed, in the girdle it breaks away in rich festoons from the surface. The ear-lobes are elongated decoratively, as in Cambodia (cf. Groslier, *ibid.*, p. 74, Fig. 39). The treatment of the head-dress (*mukuta*) points to strong influence from the Khmer ; with them the cone is repeatedly found above a broad fillet (cf. Groslier, *ibid.*, p. 11, and Coedès, *ibid.*, Plates 1, 2, and 20, 2, 3). The meagre handling of the hem of the robe, as well as the aridity of the whole composition, sets this comparatively modern, but strongly archaistic, sculpture far below the high level of the finds we owe to excavation.

CHAPTER VII

SUKOTHAI

About A.D. 1300 we find the Khmer language in Sukothai inscriptions supplanted by that of the Thai, a consequence of the triumph of the latter people in the 12th and 13th centuries. Lefèvre-Pontalis dates the definitive subjugation of Cambodia about the year 1160 (*ibid.*, p. 15). Sukothai till its conquest by Ayuthia in the 14th century remained the capital of the north, and was the seat of a powerful dynasty. Great artistic productivity coincides with this predominance.

CHIENG-MAI

Sukothai is especially influential towards the north, towards Sawankolok, and further still towards Chieng-mai. In the farthest north sculpture is still most akin to that of Sukothai. In both localities artistic achievement is remodelled on the Gupta type. Whether a Thai or Laos branch is concerned as the creators cannot in this case be determined with any certainty.

A miniature head of the 12th or 13th century (Plate 49 A and B) shows all details still more rounded and broadened than in the south, and exhibits the Siamese peculiarities in mouth and nose in an even more accentuated manner. From the last development (Plate 49 C) arose later on the weaker Laos sculpture, which has hardly any relation any longer with the crowning period of Siamese art, and is in part nourished from other sources. In this example is found also a peculiar transformation of the top-knot into a wedge.

Fournereau brought with him to Europe a head which greatly resembles the above (Plate 50, cf. Fournereau, *ibid.*, Plate 32). The asymmetric bend of the flame shows Laos influence. In Siam, as a rule, an upright, gradated form was preferred. Hence perhaps Chieng-mai should be assumed as the place of origin of this hitherto unidentified monument.

The North of Siam is a place of transition, seeming sometimes to belong to the civilised zone of the river regions, sometimes to the barbarous highlands. It must not, however, be denied its place in the rank of Siamese art centres ; for it completes the chain of influences. Just at this point the problem becomes permanently complicated and questions of date and race-affinity appear most uncertain. The plan of placing local groups side by side with chronological groups enabled us in the few examples from Chieng-mai to advance further than the geographical delimitation of styles in the rest of the Laos region allows of.

The powerful concentration of the art of Sukothai coincides with the establishment of political power. The local artistic achievement is consolidated and finds its final and definitive formula (Plate 51). So it continues for centuries. The dissimilarity of this art from that of Pitsanulok is manifest. The round dominates the modelling of the trunk. The harmony of the curves gives articulation to the full outline. The breast is prominent, almost hermaphroditic, without the contour of the hips entirely losing the elegant swing of Gupta movement. The hair meets the forehead without definite bounding line (Plate 52 A). The heavy locks mount in

well-ordered rows to the top-knot. The fleshy nose, the eyebrows, accentuated but not linear, the small mouth, are incorporated in the rounded surface of the impressive head. These peculiarities have existed for centuries, but now they yield an essence which, at any rate in the shaping of the countenance, admits of no individuality. The imposing grandeur of this composition only *seems* to stand nearer reality than the simplification of line in the neighbouring city of Pitsanulok.

The hand (Plate 51 B) belongs probably to the great Buddha. All outlines are drawn with an almost voluptuous fullness. The fingers are differentiated in their natural proportions, perhaps a reminiscence of the far-off precedent of the Mahayana. Is there in any art, cognate in place and time, a greater contrast than that between the hands from Sukothai and Pitsanulok respectively? At the same time the handling of the masses, the organic accomplishment, is in both cases equally schematic and stereotyped. In Pitsanulok the attenuated ornamentation surprised one; here the baroque massiveness stirs us to wonder.

Between these two Thai styles comes a Buddha from Sawankolok (Plate 53). All details, except the lines of the eyebrows and the line of the nose, approximate to Sukothai. But the Pitsanulok influence has already been at work, to some extent untrammelled by the Gupta tradition. The pose supplements the preceding example. This time the flame bends away sideways. Speaking generally, this Laos sculpture is cruder in effect. Possibly the geographical situation is responsible for this.

The striding Buddha (Plate 54, cf. Thompson, *ibid.*, p. 95) could thus far be attributed nowhere but to Sukothai—evidently a special local production. Iconographically it would seem to have to do with one of those scenes, usually treated in relief, from the life of Buddha—in fact, with the third miracle of the second order (Foucher, *Iconographie*, p. 166): "'The Enlightened One' tames the wild elephant whom his adversary Devadatta has let loose against him" (Foucher, *L'Art gréco-bouddhique du Gandhara*, I, p. 540). As sculpture this composition breaks away from severe frontal pose to give what is after all an extremely moderate degree of mobility. But this is sufficient to distribute the sculptural aspect over several standpoints, calculated accordingly on a change of the spectator's position, at any rate sufficient for him to see the three-quarters face. In the relief carving of Indonesia this surrender of the symmetrical pose is frequent (Borobudur); there, however, the figure is brought into relation with incident by the carriage of the hands, and is not a cultural work. In the instance before us one hand always hangs down, the other is raised in the fear-quelling attitude (Abaya-mudra). Unfortunately, the example shows clumsy reparations below the knee. Of the articulation of the lower extremities a judgment can be arrived at by comparison with the torso in the Peytel Collection in Paris (Plate 55). The compactness of the Hamburg restoration does not correspond with the good proportions of Sukothai. The treatment of the drapery exhibits variations—from the many-pleated corner lappet (Plate 51) to the plainness of this great striding figure (Plate 55) with its stunted torso; from

the clinging, transparent material, mostly leaving the right shoulder bare, to the elaborated drapery—over the hips and between the legs. The voluminous type of Sukothai persists in the northern capital, even after the loss of political independence. This late period already shows the hard conventionality of the heads to be seen at Leyden (Plate 56). Finally, the Sukothai Buddha may also occur beyond the limits of its geographical homeland. The stylistic conception must, nevertheless, be adhered to. It possesses from the first distinct characteristics—fullness of the face and body, heavy locks without fillet, modelling of the eyebrows, so that in this case the existence of stylistic development, so often questioned in reference to Upper India, can be authenticated beyond doubt, albeit its direction is other than in Europe, and in particular is derived from quite other impulses. It is to the preservation of the Gupta tradition that Sukothai owes its special place in the history of Siamese sculpture.

CHAPTER VIII

AYUTHIA

On the eastern arm of the Menam, midway between its mouth and Lopburi, lies the city of Ayuthia, " The Victorious." The last chapter of the epic that pictures the struggle of the immigrants for land to cultivate and for an independent status is connected with this name. The Thai sought rice-fields for their bodily sustenance and the blessings of civilisation to provide the necessary foundation for a national life. They found both on their road from the north to the south. The situation of the last capital renders it a bulwark against the foe, Cambodia. The decisive victory was won in the 13th century by Phra Ruang, the legendary Liberator, the Lord of Lopburi and Ayuthia. Side by side with his empire, Sukothai and Chiengmai continue to be independent for some time. Ayuthia first became the one and only capital in 1350, after the final successes that put an end to the indecisive battles of a century. Previously the place had been known as Dvarvati (cf. Fournereau, *ibid.*, p. 53).

The proximity of Cambodia explains the earliest artistic situation here, as it does in Lopburi, but with this difference, that the production of works of art can hardly have begun in Ayuthia before the 13th century.

To the commencement belong stone heads (Plate 57), in which more Khmer than Thai influence is at work. This racial element then contrived to live on to a time when its country of origin was already beginning to be impoverished artistically. The Lisbon head is marked by a certain harshness, which its place of origin accounts for. But the Buddha beneath the naga (Plate 58) is nothing else than a reproduction of the creative genius of Cambodia. None of the Thai monuments could have contributed to the composition. All details of the face modelling preserve the delicate gradations of Angkor art.

The next two Hamburg pieces are different (Plates 59 and 60), and seem to be somewhat later. The arrangement of the hair has a very stiff effect. The pregnant draughtmanship of eyebrows and eyes is in utter contrast to the delicate pictorial modelling of the Khmer. This people also often represented mouth and eye by contours, only in this case these merge organically into the fullness of the face.

Like the race itself, its peculiar type of artistic creation comes from the north. Pitsanulok gives more than Sukothai. For the first time, in the 14th century, a bronze head (Plates 61 and 62) is found to represent the national visage in the form in which it was repeated again and again in the course of the centuries. Neither the coiffure pointed in the centre is lacking, nor the nose crooked over the very full-lipped mouth, nor the crowning flame. The features seem as if superimposed upon the round of the face.

In this group the patina frequently differs. Side by side with the green tones appears also a red and a brown shade (Plate 63 B), which is due to a special blending of the metals. Like the Hamburg and Cologne bronzes, numerous examples could be cited which still preserve the expressive force of an art that is the organic achievement of proved and energetic effort.

Not materially later than bronze Buddha heads, already considered, may have arisen the type—widely disseminated everywhere—which, instead of the coiffure above the ornamented brow, built up a pagoda in tiers and pinched the ear-lobes into an ornamental case, as it is found in almost all the Cambodian bronzes—special peculiarities of the Ayuthia type (Plate 63 A; cf. also the head in the Camondo Collection, Louvre, Paris, illustrated *Cicerone*, March, 1923, Fig. 8). Of like style are many pieces, often arbitrarily assigned to particular localities, in extra-Siamese Collections.

Decadence.—While at first it was the province of Bronze to assist in the development of the Thai type, at a later date it became a source of deterioration to the sculptor. That the bronze (Plate 64) of the Musée Indo-Chinois in Paris, which the decorative scheme and overloaded ornament prove to be Brahmanical, conventionalises the Thai features, is less disturbing than the smothering of the bulk of the body by a notched and indented ornamentation, which in the clasp and the ear pendants entirely loses all relation to the general mass. Whilst in early Siamese sculpture (Plate 8) the fringes of the girdle and the bracelets melt away into the round, here every member ends abruptly, the effort to overlay everything with ornament has at last matured a not unpleasing combination of over-refined elaboration and almost Negroid simplification in the representation of the human form.

It was impossible Ayuthia could ever quite forget the teaching of Cambodia, but she ended by completely exhausting it. In the wave of creative activity that follows the 14th century the stone head (Plate 65) also comes to be transformed. The locks end in points, the lines round the eyes protrude, the eyebrows are reduced to a ridge, as in the bronze. The encircled animal mouth was already there; now a parallel line of the upper lip makes it still more pronounced, though this *may* be taken as merely a contour line. At a later date (Plate 66) it develops into the favourite moustache of the Buddha, which was worn originally only by the Prince (an example in the Ethnographical Museum at Leyden is reproduced by Roorda in Plates 15 and 16, Series 1, *Ost-Aziatische Kunst*). In the same album, again, is a Siamese bronze of similar style (Plate 17), mistakenly attributed to Cambodia. The summary treatment of this feature at a late period goes well with the simplified solution which the concluding style has discovered for the eye and all the adjacent parts. The sculptural modelling of the round as a whole disappears altogether. This final stage has a primitive look. Of the coarsened works of late date in Cambodia, Champa and East Java much the same may be said. Siam remains in its artistic development an intimate participant in the process of evolution that plays its part throughout Upper India.

As to the decadence, overproduction of objects repeated almost mechanically led apparently to mistaken views. Inasmuch as the types revert to special, often more ancient invention, this modern handiwork was taken as representing the art of Siam.

Fournereau even (*ibid.*, p. 183) says, speaking of lifeless bronzes, of a Shiva and a Vishnu (dated 1354–61), that they are " the oldest monuments of Thai art." Among the favourite subjects of this last era are the recumbent Buddha entering Nirvana, and the seated Buddha adored by an ape and an elephant. Older examples of these very familiar types could not be procured, so that they are not available for illustration.

To this class also belongs the sculpture representing Kaccayana (Plate 67), the founder of Siamese grammar. He is regarded as a helper in cases of difficult child-labour (cf. Frankfurter, " The Attitudes of the Buddha," in the *Journal of the Siam Society*, 10, 2, Bangkok, 1913). The grotesquely exaggerated bodily bulk of the religious image recalls Kubera and Ganesha in India and similar monstrosities in the Chinese and Japanese pantheons. The Siamese colossus is without the tendency to the comic that characterises the Far East. The example shows the relation of modern Siamese practice to sculpture. The old elements of modelling are reduced to the simplest formula. The head reproduces the Ayuthia type simplified to the last degree. The corner lappet of the clothing is meagre, the fingers are of equal length. This crudeness of the specially artistic elements is matched by an exuberance of ornamentation. The drapery is all broken up into decorative reliefs ; the pedestal quite loses its significance as sculpture in the fripperies of a mechanical art; flames, jewellery, cobwebs of intricate lines cover it and give the illusion of prodigious brilliance by means intended to appeal directly to the senses.

Often a standing or kneeling female figure occurs loosening her hair (Plate 68). This is the Goddess of the Earth and Mother of Mankind (in Siamese, Pra Torani). Buddha summoned her as witness of his actions against the Tempter (Mara). Thereupon she wrung out her hair, from which a river flowed forth and swept away the foes of " The Enlightened " (cf. Thompson, *ibid.*, p. 93). The same movement of the arm is made by the Bodhisattva as he cuts off his hair. The bronze art of a later date seized on the figure of the Pra Torani. While it smothers the body in the exuberance of decorative accessories, still it does preserve some remnants of original artistic power. Details indeed reveal the general progressive deadening of the sense of form. The same movement-motif is exploited in stone (Plate 69). These heavenly servitors (Gandharvas) have renounced their objective function altogether. Ornaments and draperies assume a plant-like form. This process belongs to comparatively modern times.

Qualitative judgments on Eastern art are often arbitrary matters. But a comparison of the sculpture of modern Siam, its complication of circling lines, its failure to grasp adequately the conditions of plastic art, with the sensitive outline of the early works, amply suffices to prove that the exhaustion of form is a fact, and therefore that from the 17th century onwards the existence of Siamese art can hardly be spoken of any longer. As so frequently in Asia, talent has been stifled far more by the exaggerated importance attached to sheer manual dexterity and the consequent temptation to put such dexterity in the foreground, than by the deadening effects

of religious formalism. Complete atrophy of any sense of artistic form is the price the East invariably pays for sculpture with merely technical aims and admiration for mere cleverness of hand. The man who does not feel the soullessness of these productions, curious as they are, has never known the magic of veritable creations of art.

Many a piece is to be found in European collections affording some reflection of the splendour of the great Siamese sculpture. The countenance of the Buddha throughout the Ayuthia period preserves a grandeur, inspired by the object represented (Plate 70), which atones for the premeditated elegance of the curves. Directly the handicraft element is added, the religious purpose constrains sculpture to an atmosphere that much resembles the European sentiment of the present day. This accounts for the vogue of Siamese art, which, for all that, has given Europe no single ancient example. What inspiration the works of late date can boast is merely a reflex of the creations of Sawankolok, Pitsankulok and Sukothai. These were supplemented by the currents of influence that flowed from Ligor, Prapatom and Lopburi. Ayuthia by reason of its political situation becomes heir to them all. But, whereas it may still be said to be true politically that the Siamese Empire has survived down to the present time (albeit with a new capital), the same is not true of its art, not through surrender to foreign influence, but by exhaustion of the impulse to create.

CHAPTER IX
SOIL, RACE, RELIGION

From the lands round the delta and course of the Menam river comes the comparatively scanty total of sculptures that supplied the material for our investigations. The cultural and geographical unity brought about by the configuration of this tract corresponds, as we have shown, with a certain degree of artistic unity. Sculpture, with the exception of a few definitely foreign examples, we have seen to be based upon a well-marked local sentiment. The kinship of all creations from different times and different stocks is unmistakable, though in truth it is easier to realise these delicate tendencies by feeling than words. For the Siamese, as for every inhabited area of limited extent, one biological law must be assumed—geological formation and climate had their effect on everyone living on the soil. Art-research, the province of which is also to inquire into influences, shuts its eyes to a part of the enormously complex problem if it does not take into account these deep and subtle stimuli. But nowhere does the truth emerge more strikingly as to the law of life innate in a country than it does in Siam, where for a thousand years a development continues which, though always undeniably present, oscillates between two poles which in point of biological affinity appear incredibly close to one another.

And this is the case, although the monuments themselves apprise us sufficiently of the difference existing between their creators. Siamese sculpture never belies the race of the sculptor. Anthropology, it is true, affords very insufficient data concerning the Malays, Khmer and Thai of early times. This science has hitherto neglected to take works of art into comparison. Racial identification has been achieved in this book only on the basis of comparison. For this summary procedure the known monuments of the neighbouring countries sufficed. The comparison revealed, along with other influences, one of much greater importance, the individuality of Siam. In the intricately interwoven art of peoples of Upper India there is one trustworthy guiding clue, the fact that, urged by an impulse of self-assertion, every nation illustrates its own type, its own bodily shape, just what marks it off from others. This elementary instinct, this urgency of the blood, no sculptor can escape. Sculpture in the good periods never arises as an artificial growth, but always from the stress of a living impulse bound up with the national existence. It mirrors certain ingredients in the whole struggle for rice-fields, for power, for self-assertion, in the midst of sturdy foes. These material forms subdivide and influence every stock that has settled on the soil. This explains the never-ending formation of local traditions. And here the Art history of Siam has its second law—after the law of the soil, that of the race. The anthropology of the several peoples must necessarily seek its proofs in sculpture, especially so long as its creators are in the struggling stage. This tension of the powers, this attitude of self-defence, this standing on guard, having become unnecessary, the capacity for artistic effort dries up. Previously this tension was able to give a something, an expression, an inspiration, in spite of rules, precedents and formulæ.

37

Buddhism has its share in the progress of artistic development. Not that it limited it as to subject. It was precisely in the Ayuthia period, in the course of the rapid decadence, that the number of objects represented was increased. The alteration in artistic significance is accompanied by a religious change. The sculpture of Ligor and Prapatom belongs to the Mahayana. As subjects the earliest art embraced the pantheon of Buddhism, " The Enlightened Ones " (Buddhas) and Bodhisattvas. The Little Vehicle (the Hinayana) was connected by political circumstances with the rise of the Thai race. It knows only the historical Buddha and his six earthly forerunners. The power of artistic creation of the old system was exhausted in the 13th century. The old original Pali doctrine, now once more renewed, gave no impulse, no imaginative stimulus, any longer—only formulæ. Beside the Buddha and his disciples and their ideals of self-redemption all else sank to the level of puerile decoration. Mostly it is only the historical Gautama who appears as " The Enlightened One." (For the appearance of the Bodhisattva in later times, cf. *B.C.A.I.*, 1912, p. 48). Siamese sculpture after Ayuthia, and this despite the Brahmanical irruption, may be counted as a proof of the artistic barrenness of the purely philosophical Hinayana cult. Nor can the impoverishment of creative art be bettered by national transformation; the influence of such transformations is solely objective. So the fanciful, unreasoning, superstitious form taken by the popular system does more to animate artistic capabilities than ever the intellectual edifice erected upon it could effect. Great art thrives better under the shadow of magic than in the light of reason. In view of this strangely paradoxical solution of a significant problem a clear conception of the meaning of Art is in truth the first preliminary. Only when it is identified with direct and forcible plastic expression (not with approximation to Nature or the stamp of personal idiosyncrasy) can we accept the conclusion.

The postures which " The Enlightened One " may assume in the sculptured pantheon of India are in Siam completely represented. He appears standing (Plate 9), striding forward (Plate 54), seated (Plate 53), lying down (not illustrated). In heads and full length figures such iconographic enrichments take place as to prevent discrimination between Buddhas and Bodhisattvas.

The drapery shows a development which spreads also to the west of the Peninsula, and from thence exerts a still more extended influence. Over the left shoulder hangs the outer garment. At first, and then only by exception, one finds a facing (Plate 9). As a rule the corner lappet appears, which in the Sawankolok period still retains the plain, smooth form (Plate 10) which prevails in later Burmese art and is also found in Singhalese sculpture (cf. Coomaraswamy, *Bronzes from Ceylon, chiefly in the Colombo Museum*, Colombo, 1914, Plate 15). On the Indian continent the pleated lappet of the Pitsanulok sculpture is a rare occurrence (cf. Smith, *A History of Fine Art in India and Ceylon*, Fig. 130). Siam shares this special form of drapery only with Burma (from amongst the numerous examples cf. K. Seidenstücker, *Die Buddha-Legende in den Skulpturen des Ananda Tempels in Pagan*, Hamburg, 1916, Fig. 51).

As regards the question of build, the race chooses from among traditional religious models. The canonical thirty-two corporeal signs of the Great Being are not stringently binding. The *urna*, originally a ring of hair above the root of the nose, sculpturally a knob, is absent in Siam, as it is, generally speaking, in Upper India (an exception in Groslier, *ibid.*, Plate 3 c); it would have interrupted the broad surface modelling. Instead we find the *ushnisha*, the outward bulge of the skull, given over entirely to the play of fancy, without excluding the simplest solution. How well the formalism of the Hinayana and the decorative instinct of the Thai craftsman harmonise in the long run is demonstrated by the punctilious observance of the demand for equal length of the fingers (Plate 67).

CHAPTER X
CHRONOLOGY AND DEVELOPMENT

Only at a late date do the inscriptions found in Siam refer to existing works of art. It was therefore, despite the preliminary studies of Voretzsch, peculiarly difficult to undertake a chronological arrangement of the monuments. At the same time the activity of foreign races in frontier regions can be authenticated from sound historical sources. So, if foreign characteristics occur in sculpture, it follows that this sculpture belongs to the time of foreign domination. We know of the immigration of the Thai as well as of their empire in definite localities. There they have left behind works of art, some qualities of which were derived from their native soil. Reference to races and their period of domination may be regarded as in most cases establishing the chronology of the sculpture of Siam.

The demonstration of this thesis revealed to us a somewhat unusual course of development. The Indian Gupta importation from Ligor marks the beginning. A high civilisation already in existence settles on virgin soil, carried yet further by the Malays in their seaward advance, whose art between A.D. 400 and 900 is already verging towards over-refinement. There is a simple and a mature stage in Prapatom as in Java. Stimulated by the art of the south, and by the works round about them inspired by the Gupta, there arises the first special Thai centre, Sawankolok in the north. Here, from the 8th century onwards, the typical characteristics of the national workmanship are established for the first time on a firm foundation. The necessary corollary, a free independent invention, grows torpid with the sinister rapidity of tropical countries. The oscillations between neighbouring stimuli and popular demands lead directly to a Siamese type which the descriptive text was bound constantly to take into account.

Contemporaneously with the art of the north, Lopburi is founded on the Middle Menam, a door of entry for Khmer sculpture. This in especial influences works in stone ; it joins the eyebrows into one continuous line, bores in deeply the corners of the mouth, frequently cuts the hair short with a fillet across the forehead. In opposition to foreign influence, after the turn of the year 1000, stucco sculpture established itself, whilst it makes nose and coiffure conform with the Siamese pattern. Bronze heads subsequent to the victory of the Thai are exclusively confined to the north.

The fact of Khmer influence goes along with the political ascendancy of that people and affects the whole of Southern Siam. The real nursery of the national creative work lay in the north. Sawankolok, Sukothai and Chieng-mai were never entirely overcome by alien influence, and developed accordingly the formal type they had inherited from India. Side by side with these localities, and in union with Lopburi, Pitsanulok became the seat of the last definite solution. Stimulated by the heavy-locked, delicately moulded Sawankolok head, the pattern of the Thai type of figure emerges. At first the hair is modelled in small knots, as at Lopburi ; later in spiky points, crowned decoratively with the flame. In place of the modelling of the

eyebrow and the bridge of the nose a ridge appears. Variations arise, in fact a reversion to the old unconfined coiffure; but even then the linear treatment of the face still remains.

To a real modelling of the face only the later style of Sukothai and Chieng-mai holds good. There, too, a hard border-line round the eyes is eventually developed, and this is carried on in the same way to a broadly moulded bridge of the nose. The hair fillet is hardly ever found, the heavy locks are still there. Between the sculpture of Sukothai and that of its neighbour Pitsanulok stands the shadow of Gupta art, an old inheritance the burden of which the newly arrived immigrants were not obliged to take over.

As an amalgam of all styles comes the art of Ayuthia (about A.D. 1250), influenced from the east in stone-sculpture, from the north in bronze, doomed to an early death by its lack of impulse, as to the value of which we must not be led away either by the fertility of the artists themselves nor by the mistaken zeal of critics, who have devoted a disproportionate amount of effort to the publication and discussion of these objects. In stone especially an abundant Khmer influence is manifested, which little by little is overmastered by the dominant Pitsanulok style in bronze. Very often, at a still later date, a reminiscence of Cambodia chimes in. The straight bounding line of the coiffure may appear in a fully developed decorative bronze. The conventional type with sickle-shaped eyebrows, thick lips, hooked nose and spiky hair outlives the centuries.

The original living freshness, the ripe appreciation of form, is succeeded by a stunting of the special artistic half-unconscious creative impulse and the discovery of mere tricky dexterity of hand. Judging the law of Siamese development by its human representations, a more or less peaceful rivalry with cognate races, whose civilisation is brought low, not by destruction, but by absorption, would be deduced. The neighbouring artistic achievement reacts on the place of contact as a stimulant, while at the same time constraining the Thai to the development of their own special and particular qualities.

The most naturalistic stage is found at the beginning; formalism and a reversion to an easy and convenient, apparently primitive, simplification at the end. Sculptural progress runs its course between the rhythmic system of India, the affected gracefulness of the Malays, the loose repose of the Khmer, till it reaches the intensity of expression characteristic of Thai art. Later on, led astray by Siam, in the hands of the Laos it falls into complete decadence. The 15th century, which may be regarded as the turning-point in the history of Upper India, sees the difference of all other influences but those of the Thai-Laos, whose productions have in recent centuries tended to dominate Upper Indian art.

CHAPTER XI
FORM AND MATERIAL

It is not to be wondered at that in a land where every racial movement was at once reflectic in the plastic arts, the material employed should likewise have acquired a determining influence. Stone brings conservatism in its train. This material was used by the Malays, chiefly as an adjunct to architecture (for example, in relief work), and it was the Khmer who first utilised it for sculpture in the full sense of the term. In Siam a kind of grey sandstone is used ; slate is less common ; reddish sandstone is only found subsequently to the Ayuthia period. Stone retains the impress of the Eastern stimulus more than any other material, and never abandoned such peculiarities as the straight bounding line of the hair.

Clay is revolutionary. It alone admits of treatment by means of colouring applied to the mass ; gilding also occurs. Larger examples show a moulded over-layer covering a harder nucleus (Plate 26 B). The material admits of unlimited adaptation to the racial type. Portraiture can meet with ready success in clay, and is susceptible of exploitation like a formula.

Bronze implies firm solidity. Of the different alloys only the chemist can pronounce authoritatively. This task Coedès undertook exhaustively (*ibid.*, p. 13). Gilding is the rule and creates marvels in the way of patina. Bronze demands above all the invention of mechanical formulæ corresponding to the Indian technical prescriptions (Cilpa Castras), and more especially determines the fate of Siamese art.

The formal process can be traced in body and face. As in India, the former is understood, not as a framework of forces that manifest their play in joint and muscle ; not beings capable of action are represented, but rather earthly receptacles of supernatural powers—raised high above human limitations, only related to the actual body where it lifts most lightly from the earth in the dance and the gestures of the maker of magic. So with the gracefulness of Prapatom, the firm solidity of Sawankolok, the slimness of Lopburi, the tense fulness of Pitsanulok, the swelling, hermaphrodite-like bosom of Sukothai, the stiffened ornamentation of Ayuthia.

The Northern Thai, in particular, consolidate framework and figure in a vigorous frontal pose, in which the movement of the hands assumes a rhythmical, deep-seated articulation. The special instance of the striding Buddha in the mathematical regularity of his three-quarter face pose confirms rather than contradicts the statement. Everything recalls a work in relief. Widespread wings of drapery often form a kind of sculptured wall, a background, on which the half-round is developed. In the composition as a whole everything is subordinated to the curve ; all details are circumscribed by segment lines. The system stifles every naturalistic impulse.

In contrast with this art the Khmer show a far wider plastic range. They stretch the skin of the surfaces over a body that looks more like a plant filled out with protoplasm than a human form. Their softening down of the transitions, their

sensitive modelling of the sculptured surface, could not remain without influence on Siam. To this day the suggestion they give is recalled by the modulated movements of modern goddesses and dancing women.

In the end the Thai had developed a formula out of this, as out of every impulse. Their art seems to obey a higher law of suitability, of adaptation of means to ends. In every locality there results from the pre-conditions of blood and soil the type, the definite formula, that answers most completely to the local needs. Once discovered, clearly realised, worked out in every detail, it renders further invention superfluous and meaningless. This machine-like solution of the artistic problem is facilitated by the mechanical processes of the highly perfected craft of bronze-casting. It gains permanence through the nice correspondence of civilisation and race. It was the riddle of race that sent Sculpture forth again and again in exploration, that mingled again native, cognate and foreign elements. The Thai and their triumph finally set an end to changes of form.

CHAPTER XII

APPRECIATION

Sculpture in Siam expresses the essential truth regarding many peoples. Thus it became the reservoir and guardian of forces which have long ago gone under in the whirlpool of changing events. There is, therefore, no such thing as a Siamese sculpture with separate and distinct stylistic epochs—*only a sculpture in Siam*. It is a compound art like almost every other activity in the circle of Indian life. One preponderate occurrence set the final and definitive stamp upon it, determined its permanent aspect—to wit, the immigration of the Thai. To note how the heart of this people propels ever new currents of blood to the surface is to catch the essential character of Siamese art. Thus the Thai creations, the only works hitherto criticised, become the last link in a chain of evolution. Their formalism, born of racial necessities, deserves a gentler verdict than that hitherto pronounced by European critics. This final stage of a mighty development alone possessed the possibility of permanence. At the same time the products of modern industrial art, fruit of the indiscreet application of an amazing dexterity of hand, must be excluded from any serious consideration of the subject.

The early stages of Siamese art have seldom met with intelligent appreciation. How just at the very first in artistic production contending forces meet and do battle is proved convincingly by the resultant forms. The intensity of this activity suffices to place the monuments of Siam in the ranks of great Art. Sculpture in Siam has produced works of the highest impressiveness of form, especially in the frontier districts, and at times of stress the creative forces were at their strongest. In the interplay between observation of Nature and the precepts of the schools rigid law at first carries the day ; but once first principles were firmly established, it becomes in its turn subject to more immediate and pressing considerations. As a whole, the course of Siamese development implies something more than a local school confined within definite boundaries. It reveals something of an artistic upheaval, it shows a change of type that has been active in similar ways on other parts of the continent. The laws which we have found to prevail in Siam will probably turn out to be applicable to the rest of Upper India. A lucky chance may well supply fresh historical data, and this, combined with a few typical finds, may provide us with a key to the history of Upper Indian sculpture, and enrich our store of experience with a series of mighty works of art.

TABLE OF DATES AND LOCALITIES

Ligor, Malay Peninsula. Indian Gupta Art.
 Commencement of the 7th century and later.

Prapatom, Southern Siam. Malay-Indian Art.
 7th to 10th centuries.

Sawankolok, Northern Siam. First Thai Art.
 8th to 10th centuries.

Lopburi, Mid-Siam. Wave of Khmer influence.
 9th to 13th centuries.

Pitsanulok, Northern Siam. National Thai Art.
 11th to 14th centuries.

Sukothai, Northern Siam. Indian tradition in Thai Art.
 12th to 14th centuries.

Ayuthia, Mid-Siam. Conglomeration of all styles and decay.
 13th century to modern times.

LITERATURE AND ABBREVIATIONS

JOURNALS

Arts et Archéologie Khmers, Paris.

Bulletin de la commission archéologique de l'Indochine, Paris.

Abbreviated *B.C.A.I.*

Contains, 1909: E. Lunet de Lajonquière, " Rapport sommaire sur une mission archéologique," and " La domaine archéologique du Siam."

Contains, 1912: Same author, " Essai d'inventaire archéologique du Siam."

Bulletin de l'école française d'extrême-orient, Hanoi.

Abbreviated *B.E.F.E.O.*

Contains numerous papers on Siam.

Cicerone, Leipzig (special numbers devoted to Oriental art), 1923.

Journal of the Royal Asiatic Society.

Abbreviated *J.R.A.S.*

Contains. 1895: R. Sewell, " Some Buddhist Bronzes and Relics of Buddha."

Contains, 1904: O. E. Gerini, " Siamese Archæology."

L'art décoratif, Paris.

Contains, 1913: H. d'Ardenne de Tizac, " L'art bouddhique au Musée Cernuschi."

Ostasiatische Zeitschrift, Berlin.

Abbreviated *O.Z.*

Contains: Year 5, Parts 1 to 4, and Year 6, Parts 1, 2: E. A. Voretzsch, " Ueber altbuddhistische Kunst in Siam."

Rupam, Calcutta.

Contains in No. 5: E. A. Voretzsch, " Indian Art in Siam."

Journal of the Siam Society, Bangkok.

T'oung Pao, Leyden.

Contains: 1897 and 1909, P. Lefèvre-Pontalis, " L'invasion Thaie en Indochine."

BOOKS

E. Aymonnier, *Le Cambodge*, 2 vols., Paris, 1908.

C. Coedès, " Bronzes Khmers," *Ars Asiatica*, Vol. V, Paris, 1923.

A. Coomaraswamy, *Catalogue of the Indian Collections in the Museum of the Fine Arts*, Boston, U.S.A., 1923.

—— *Bronzes from Ceylon, chiefly in the Colombo Museum*, Colombo, 1914.

K. Döhring, *Buddhistische Tempelanlagen in Siam*, 3 vols., Berlin, 1920.

A. Foucher, *Étude sur l'iconographie bouddhique de l'Inde*, Paris, 1900 and 1905.

—— *L'art gréco-bouddhique du Gandhara*, Vol. II, Paris, 1918 and 1922.

BOOKS—*continued*

G. Ferrand, *L'empire sumatranais de Çrivijaya*, Paris, 1922.

L. Fournereau, *Le Siam Ancien*, Vol. I, Paris, 1895.

O. E. Gerini, *Siamese Archæology*, in A. C. Carter's *The Kingdom of Siam*, New York, 1904.

G. Groslier, *Recherches sur les Cambodgiens*, Paris, 1921.

R. Grousset, *Histoire de l'Asie*, Vol. II, Paris, 1922.

N. J. Krom and T. van Erp, *Barabudur*, The Hague, 2 vols. of plates.

Mission Pavie, Vol. II, Paris, 1898.

H. Parmentier, " Les sculptures chames au Musée de Tourane," *Ars Asiatica*, Vol. IV, Paris, 1922.

T. B. Roorda, *Oost-Aziatische Kunst*, 1 series, The Hague, 1920.

K. Seidenstücker, *Die Buddha-Legende in der Skulpturen des Ananda-Tempels in Pagan*, Hamburg, 1916.

V. A. Smith, *A History of Fine Art in India and Ceylon*, Oxford, 1911.

C. Schwalbe and H. Fischer, " Anthropologie " in *Die Kultur der Gegenwart*, Leipzig, 1923.

P. A. Thompson, *Lotus Land*, London, 1906.

R. O. Winstedt, *Malaya*, London, 1923.

K. With, *Java*, The Hague, 1920.

—— *Asiatische Monumentalplastik*, Berlin, n.d.

INDEX

INDEX

PLATES

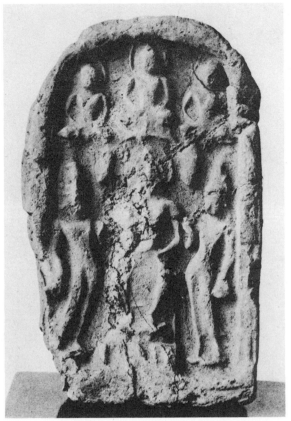

A

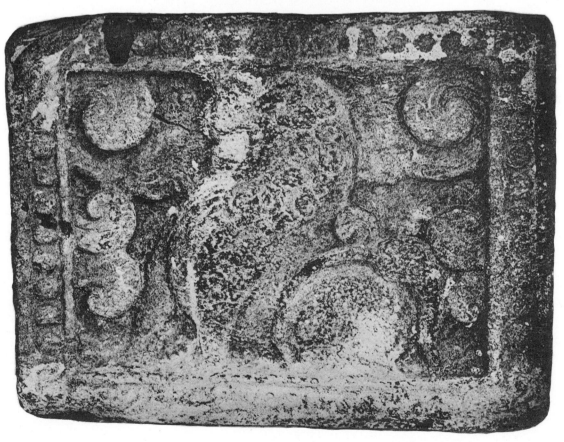

B

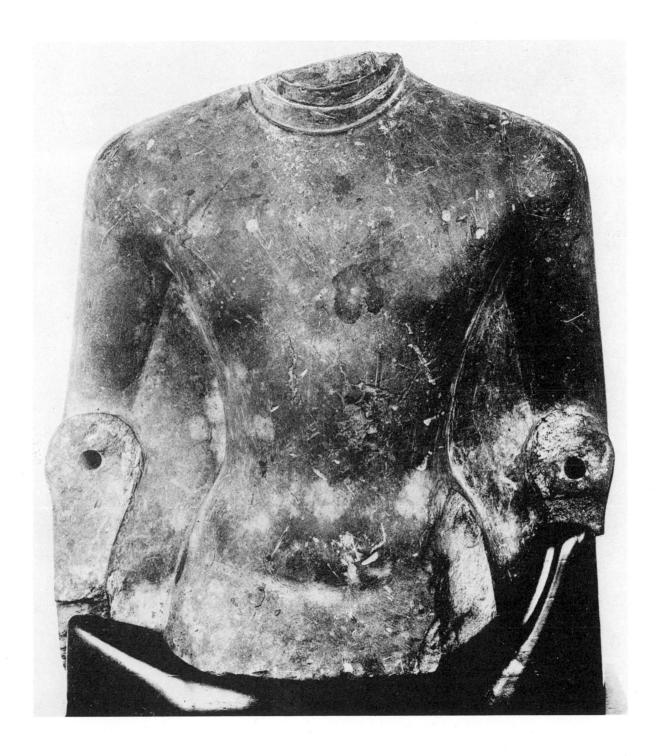

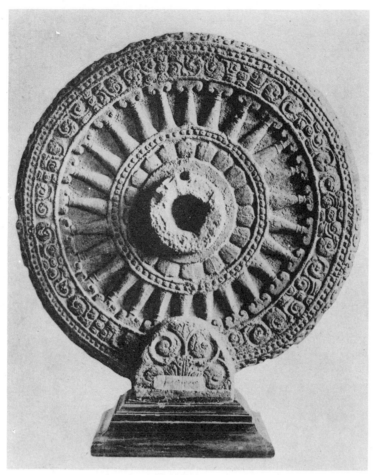

A

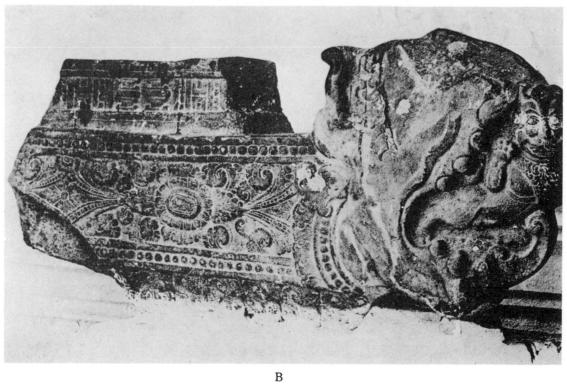

B

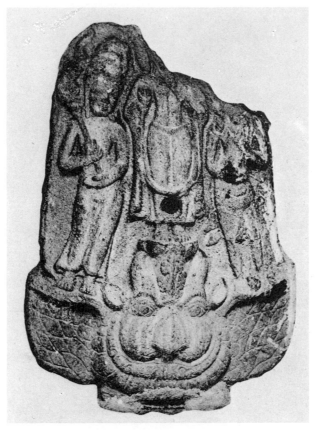

A

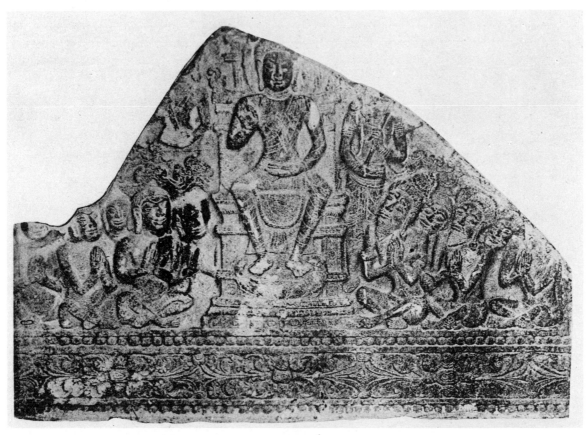

B

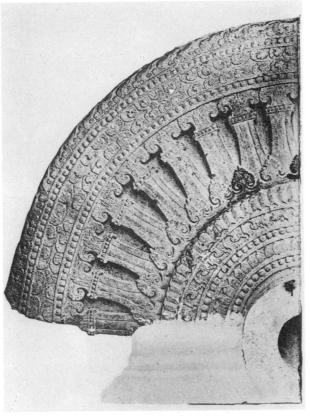

A

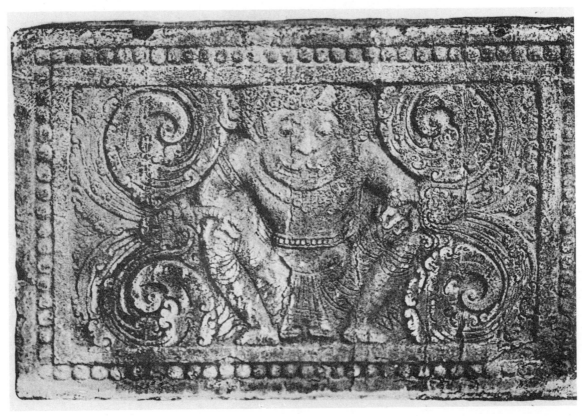

B

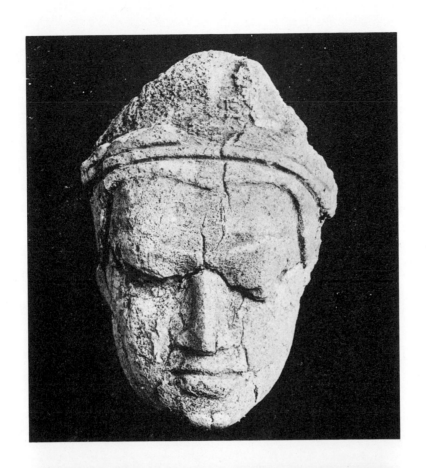

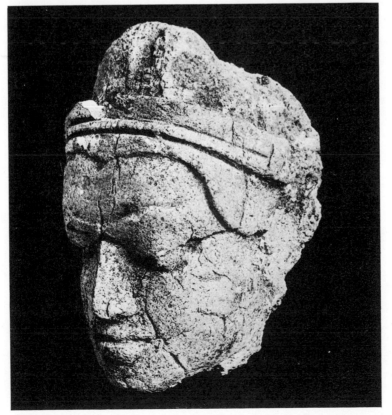

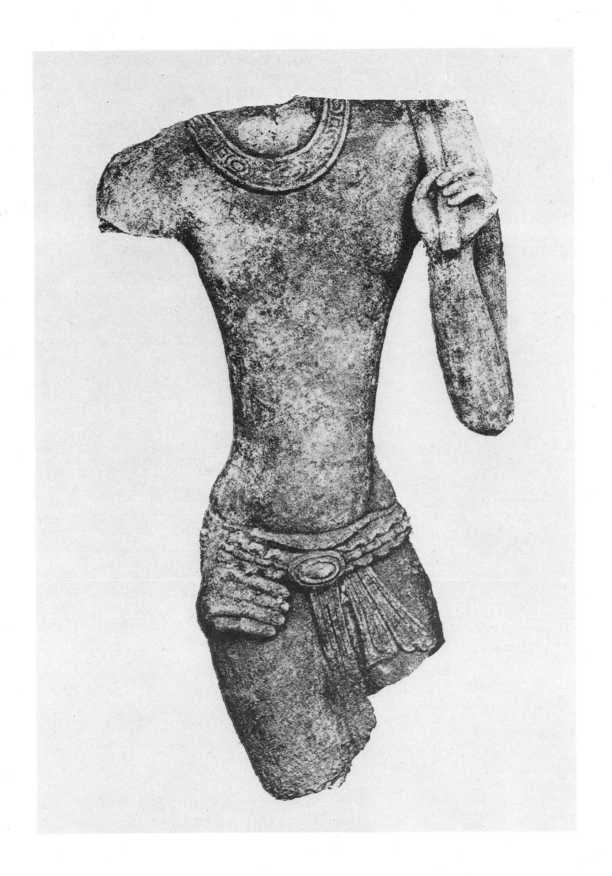

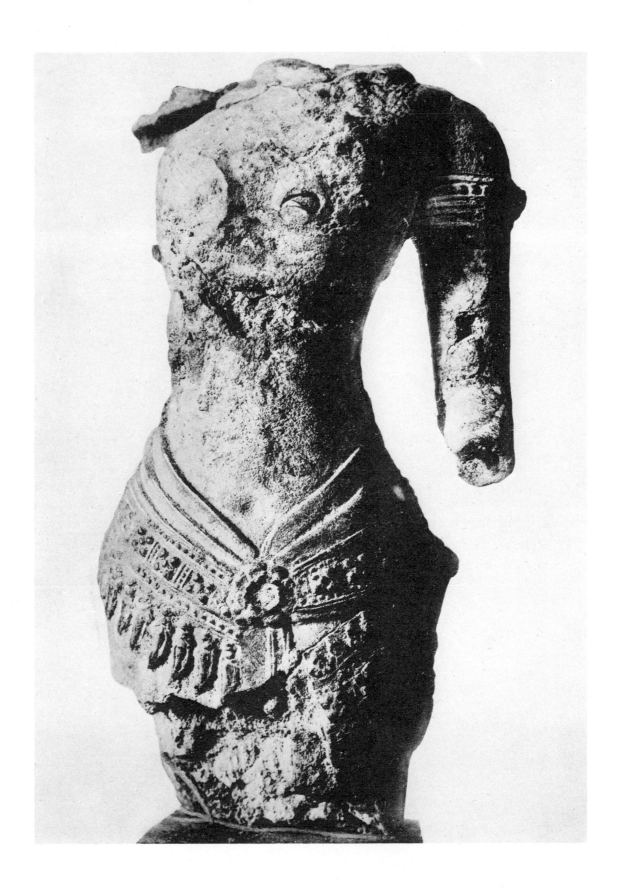

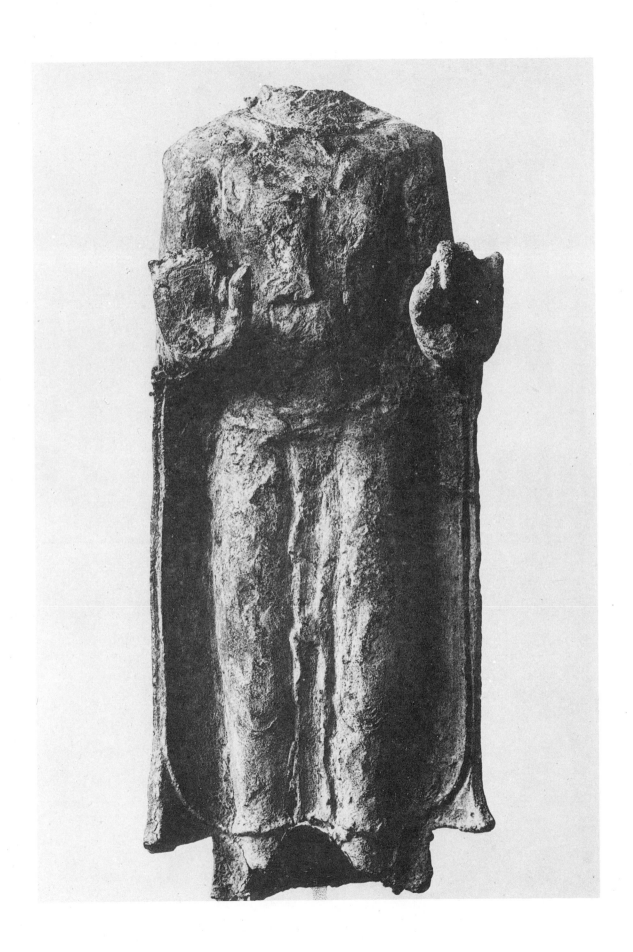

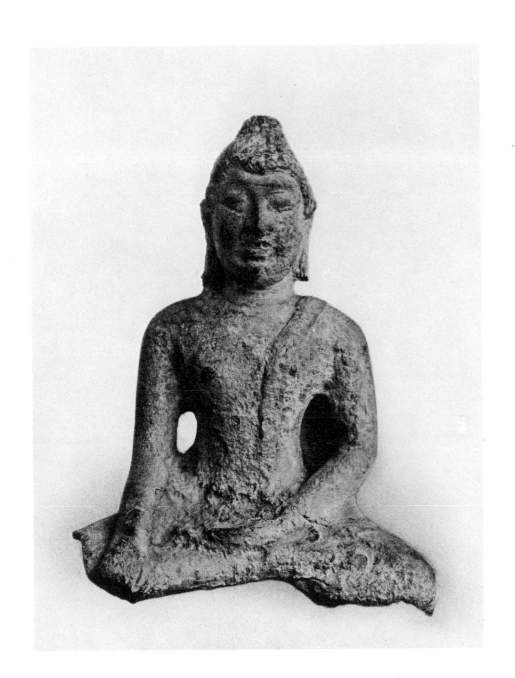

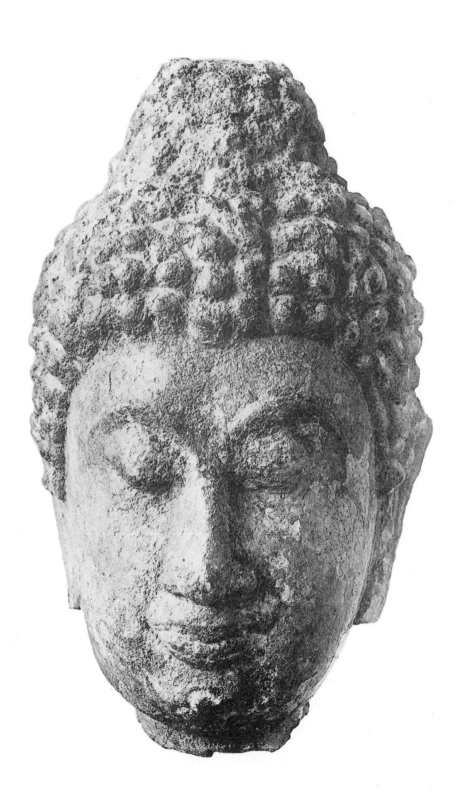

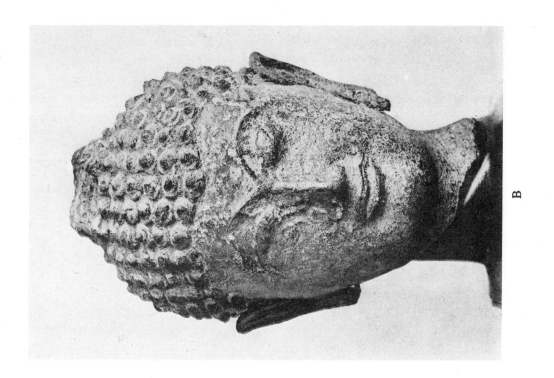

B

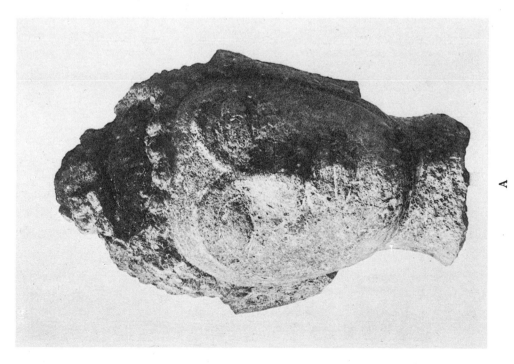

A

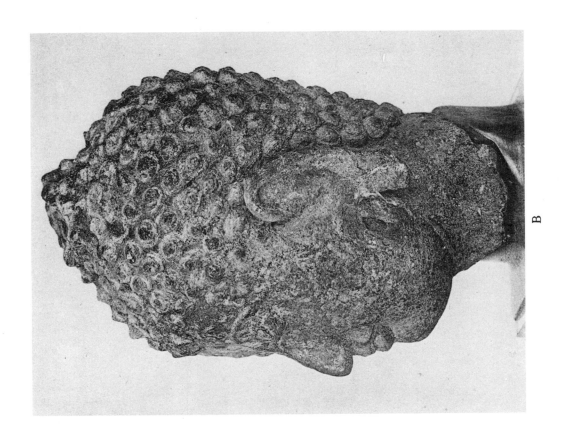

B

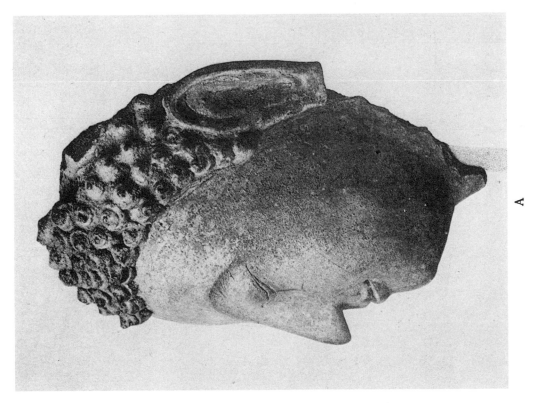

A

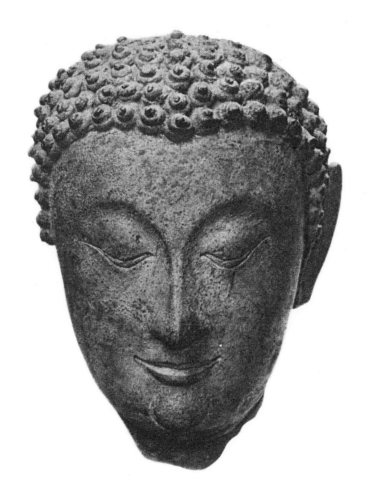

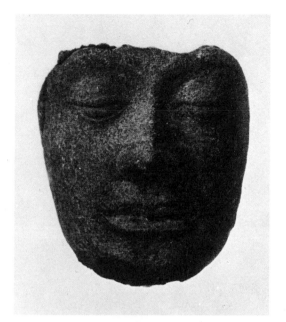

A

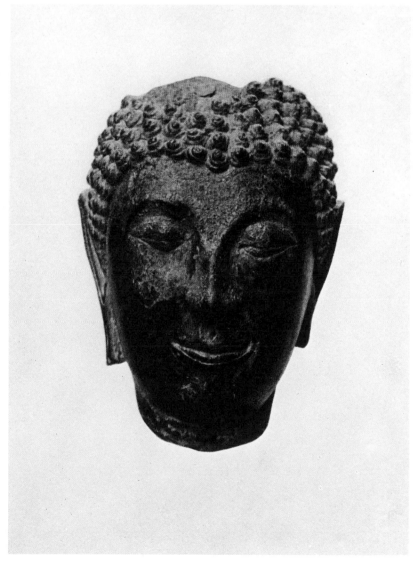

B

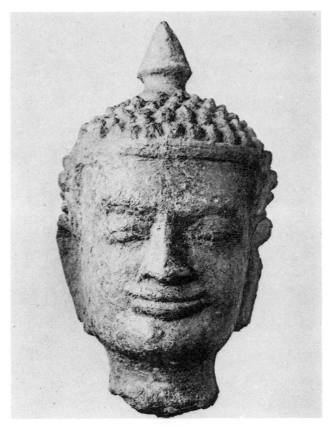

A

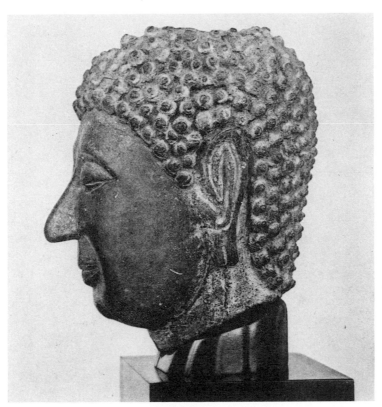

B

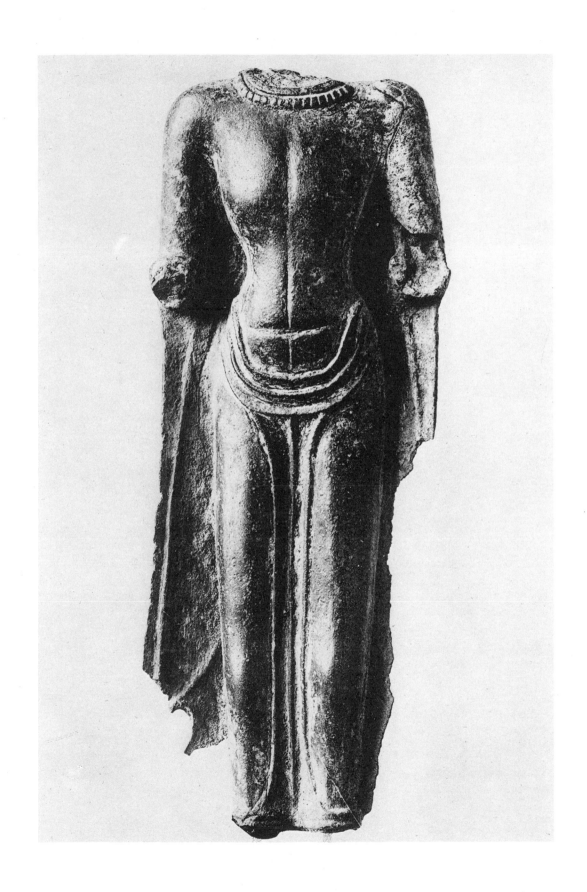

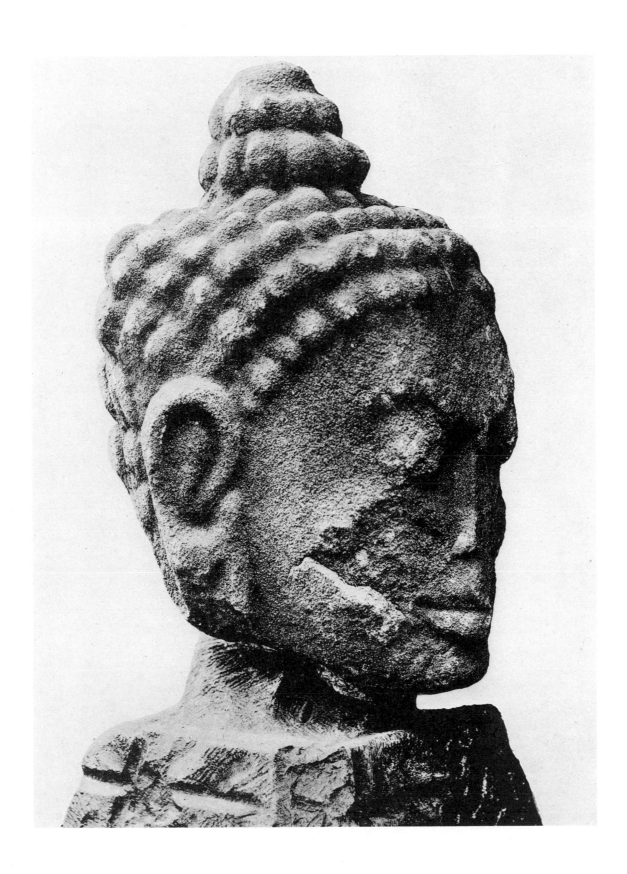

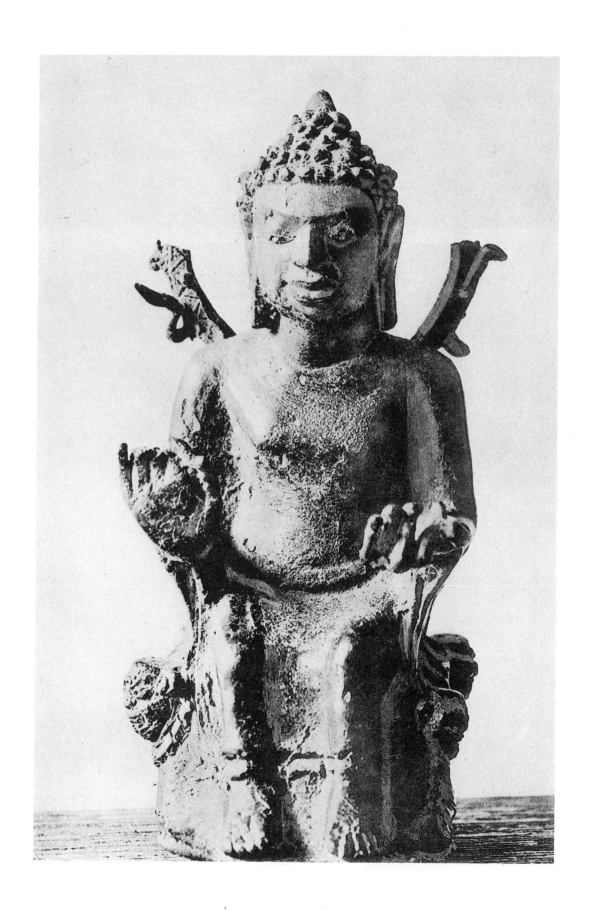

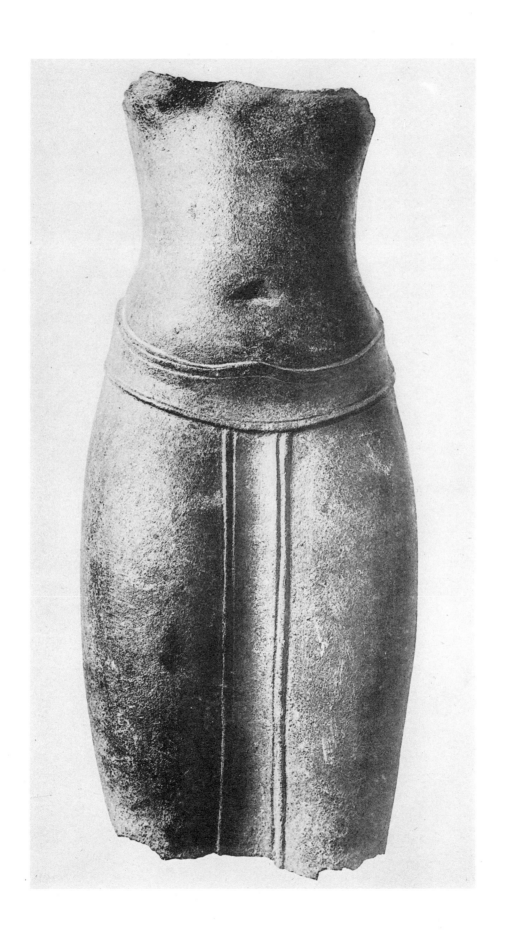

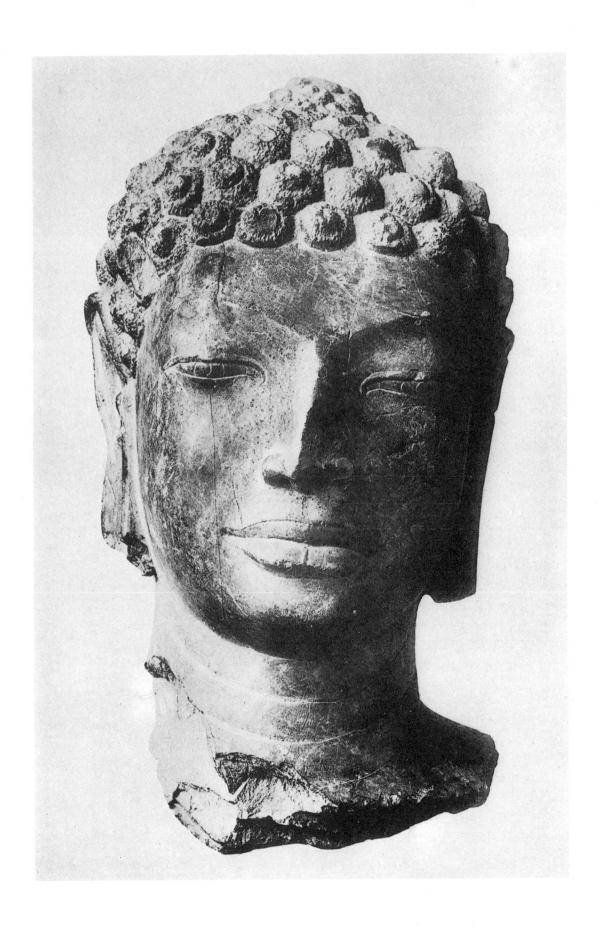

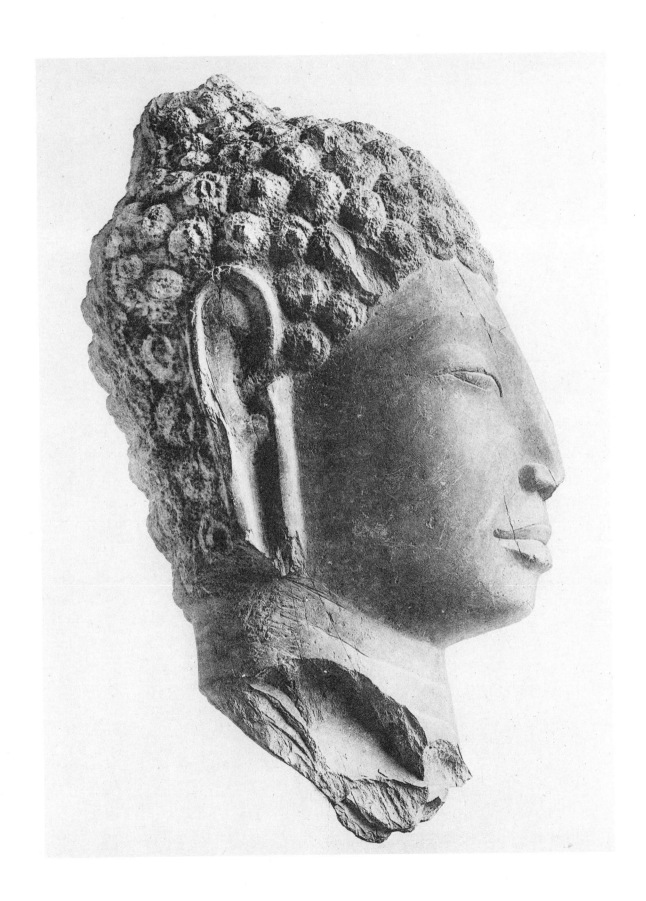

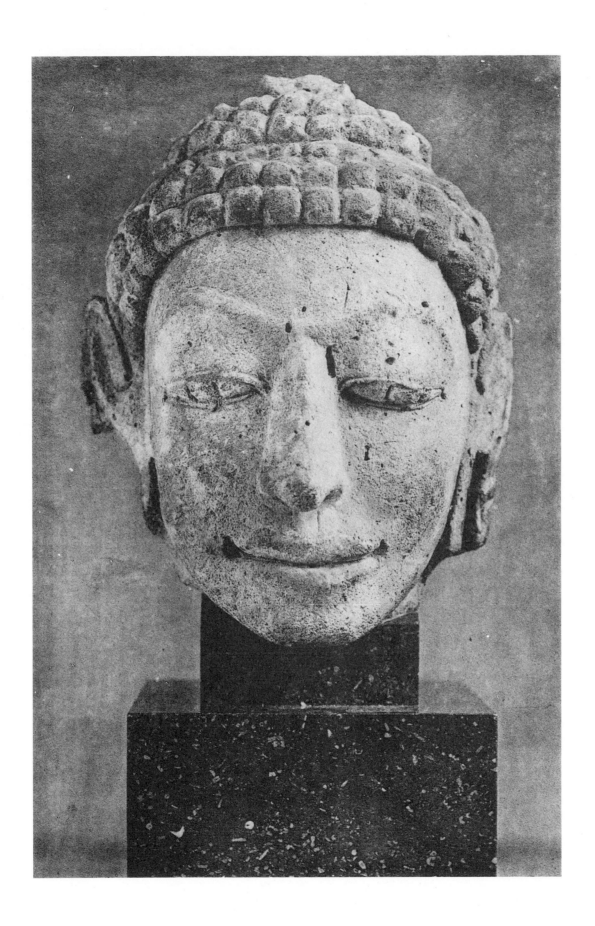

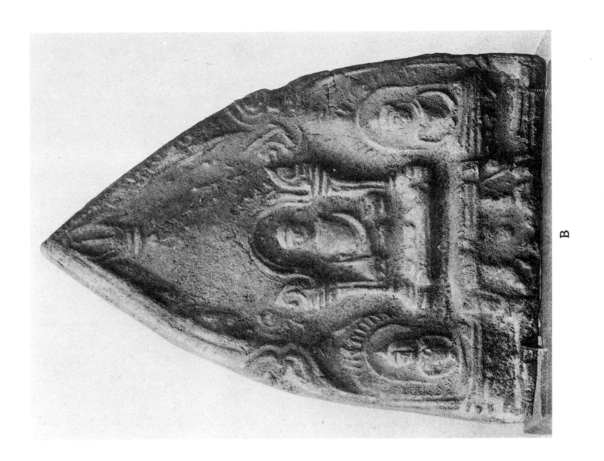

B

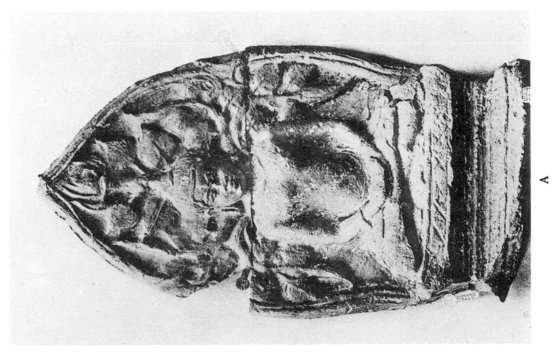

A

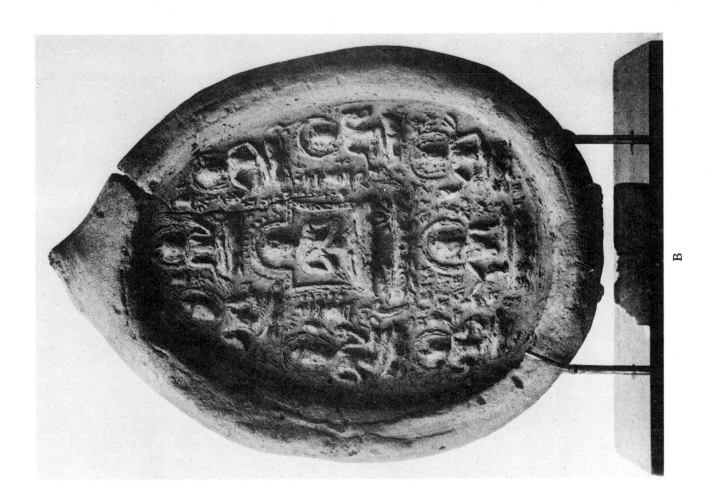

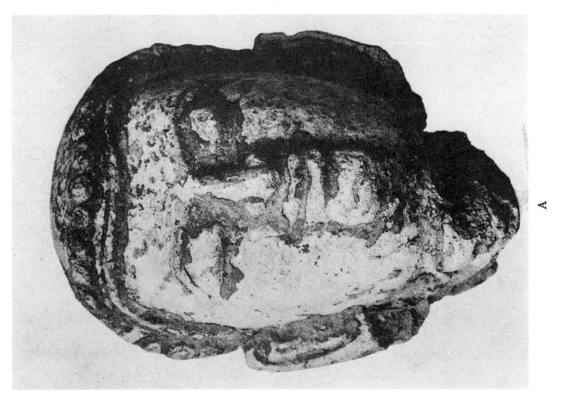

B

A

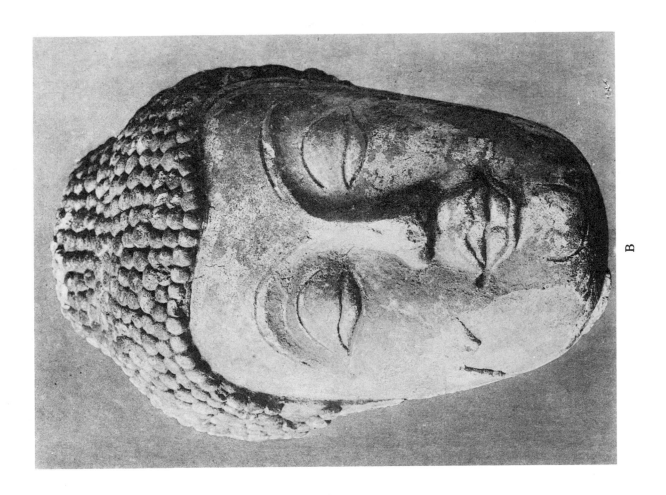

B

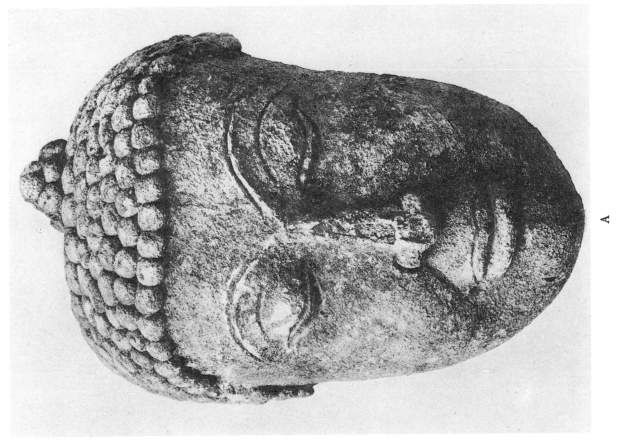

A

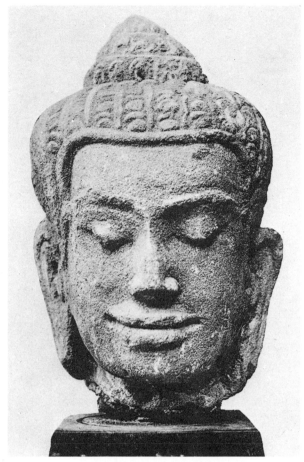

A

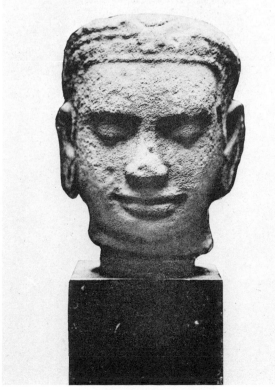

B

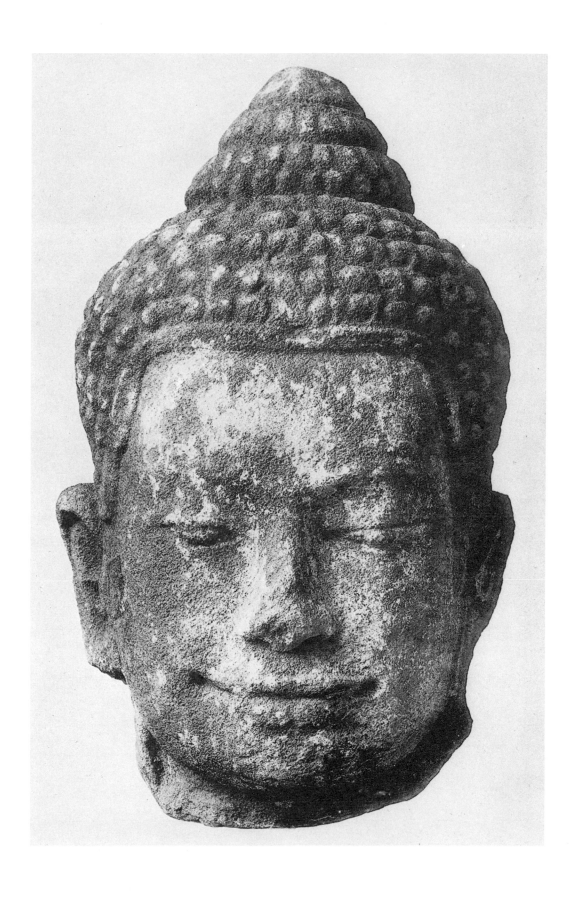

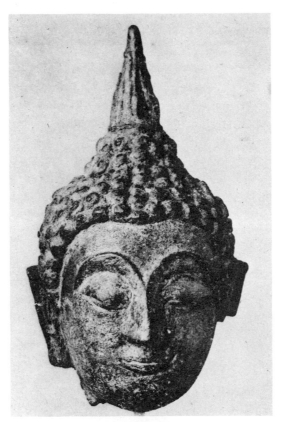

A

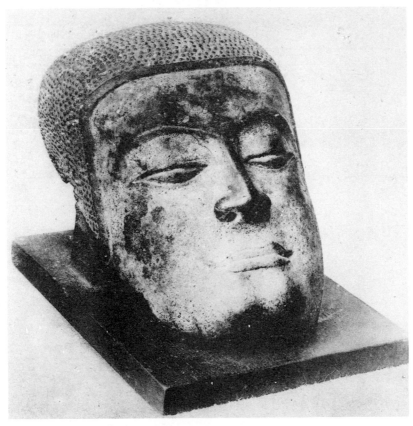

B

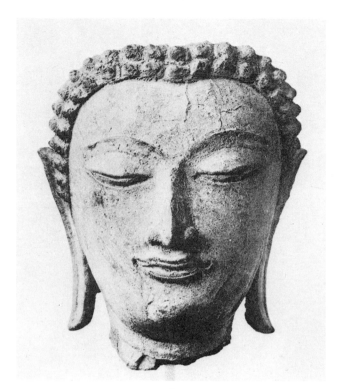

A

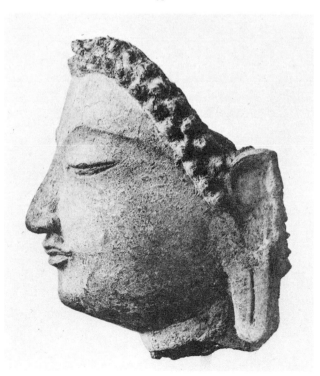

B

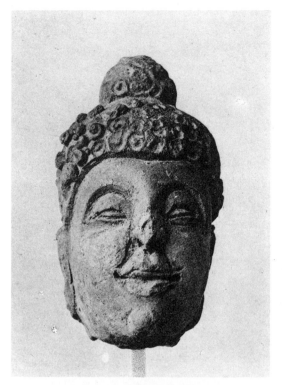

A

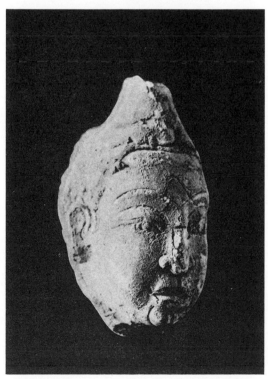

B

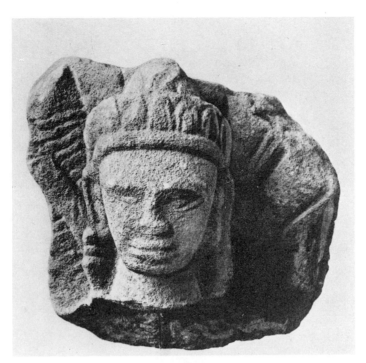

A

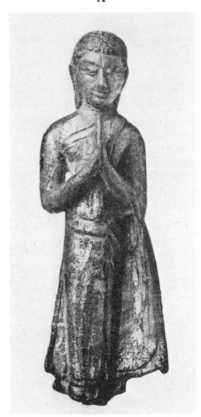

B

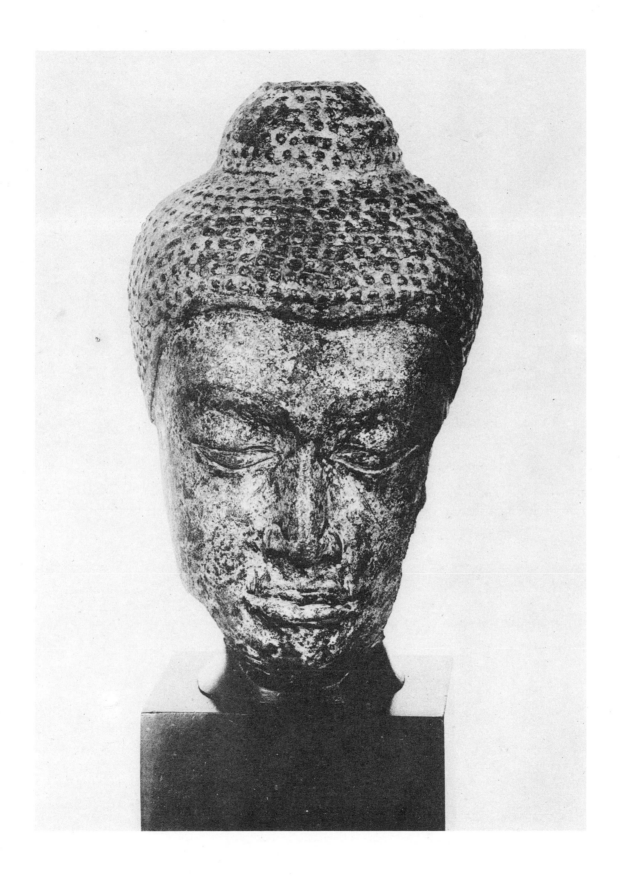

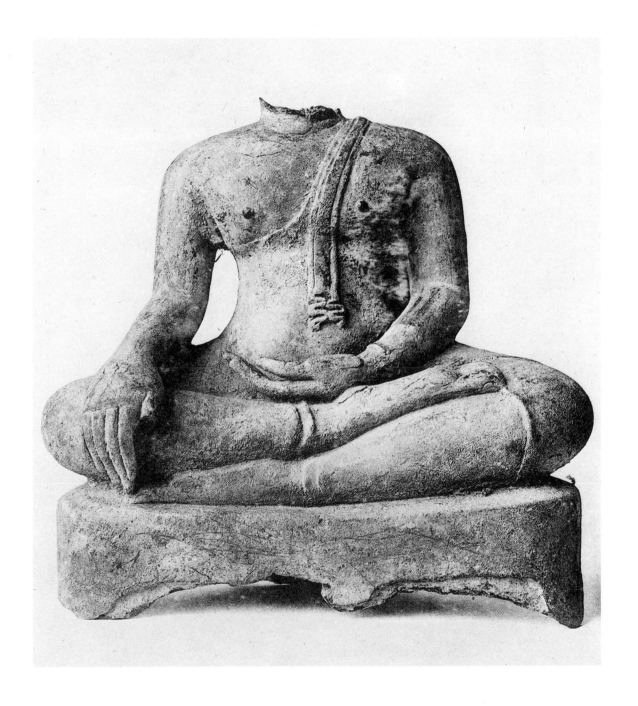

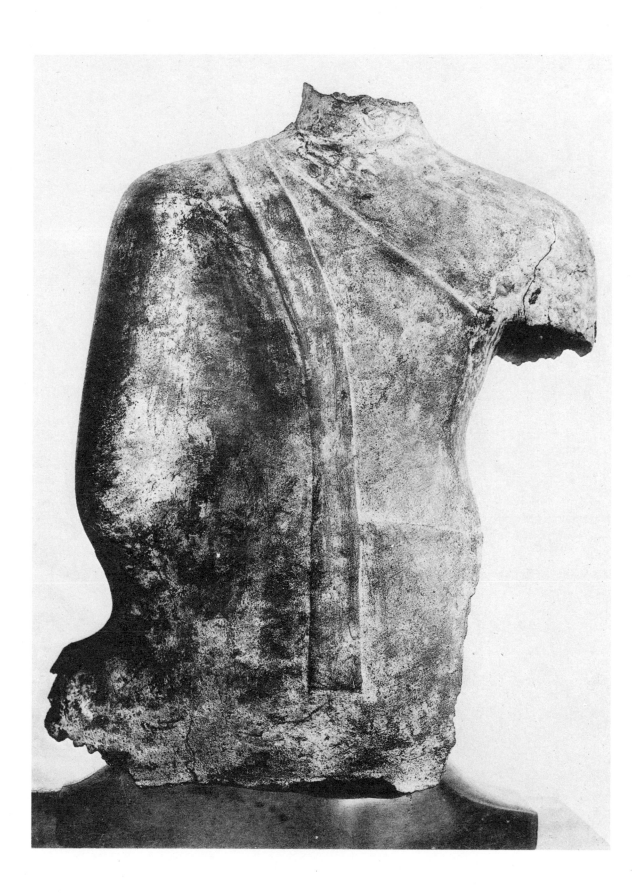

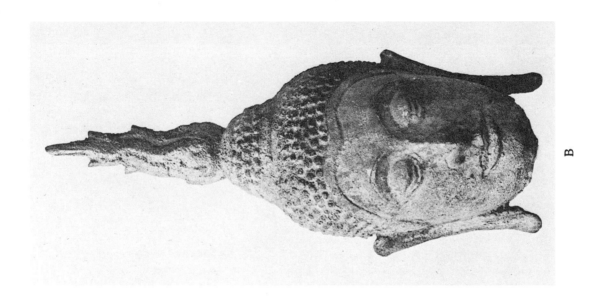

B

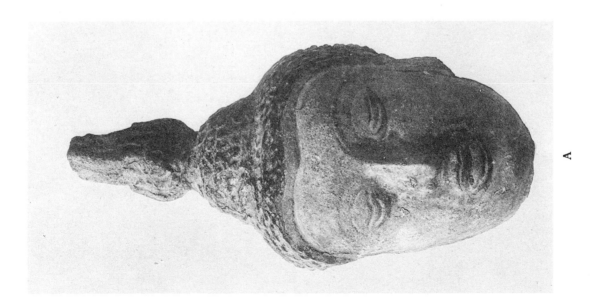

A

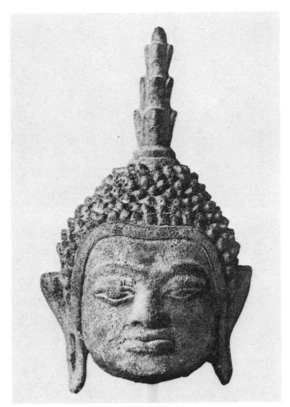

A

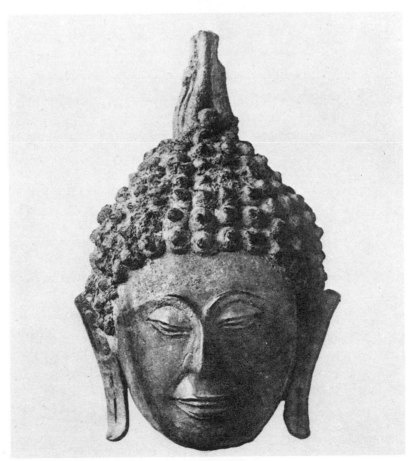

B

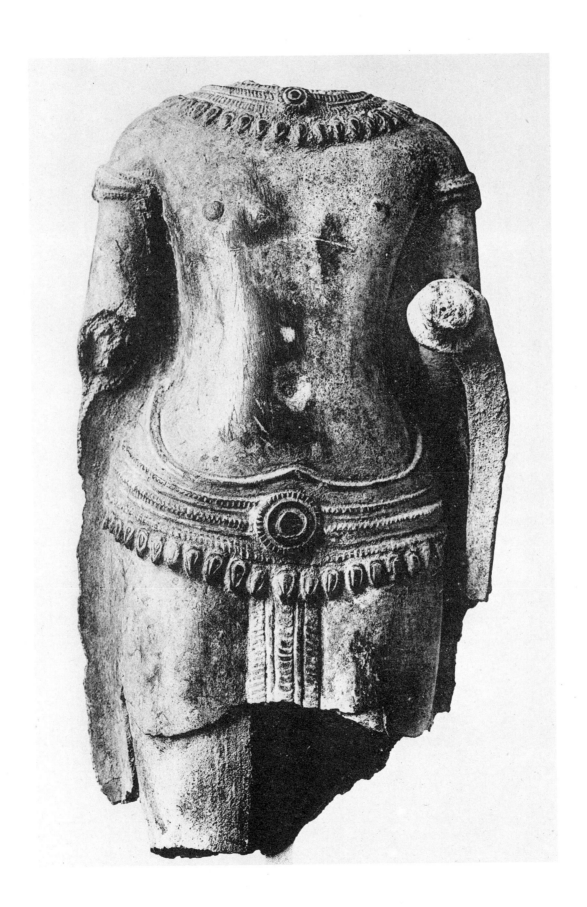

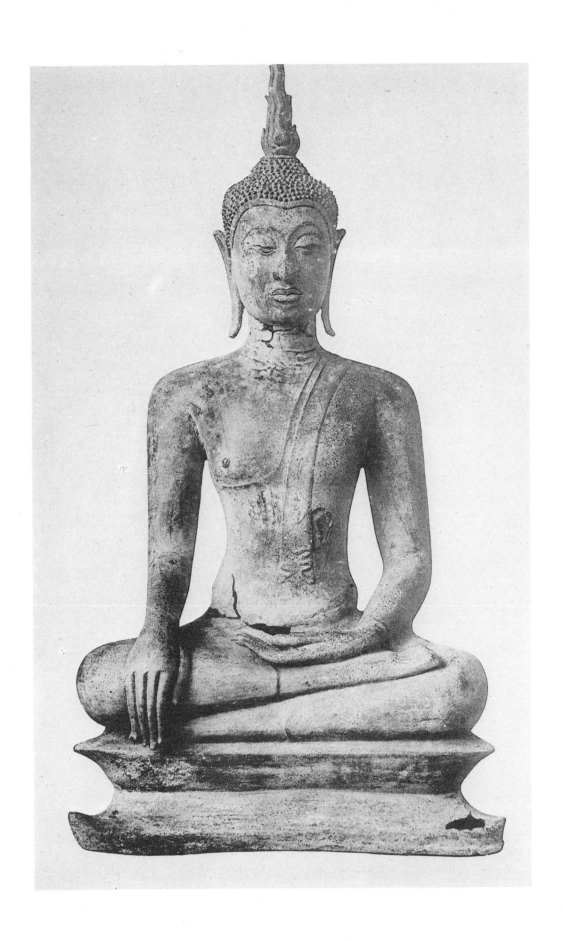

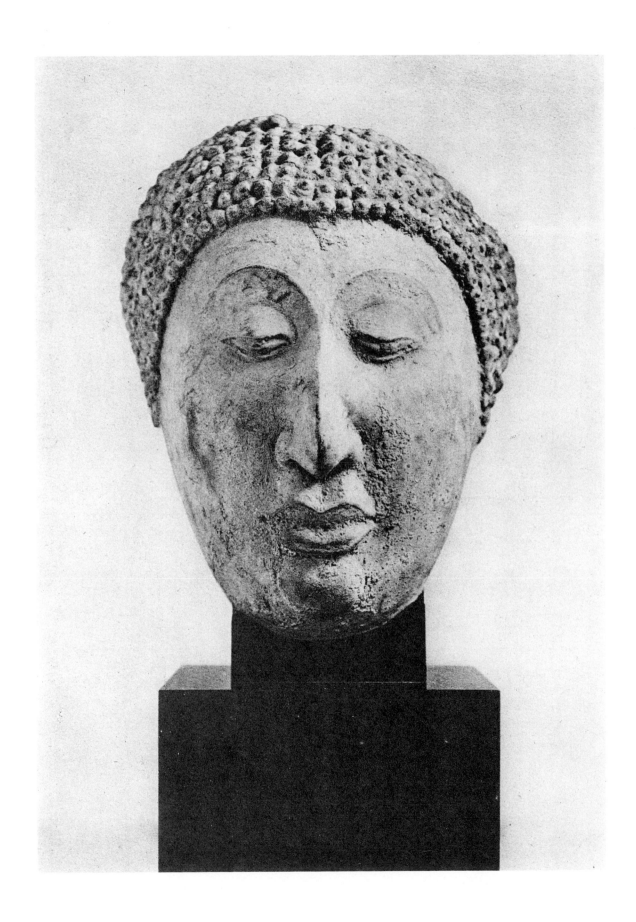

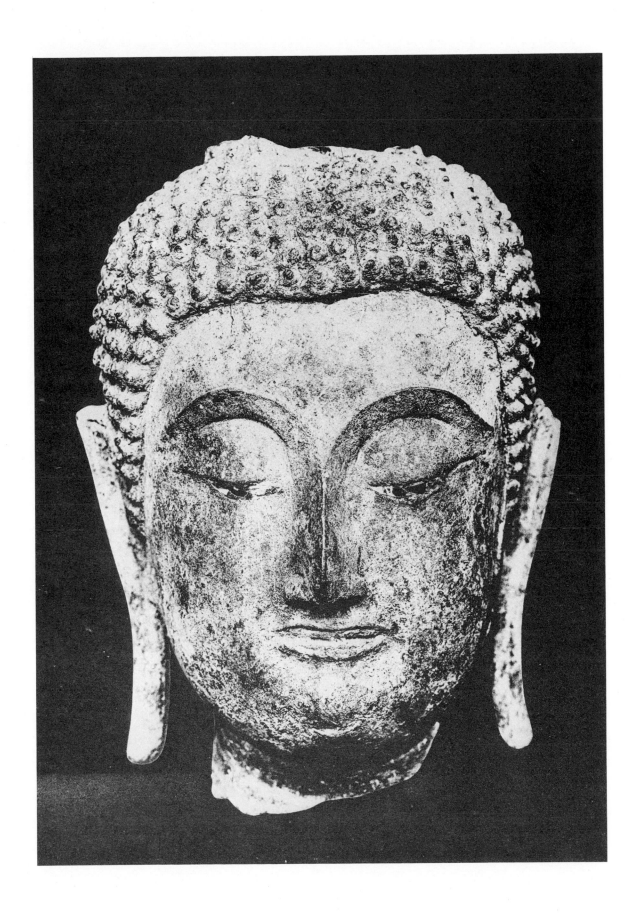

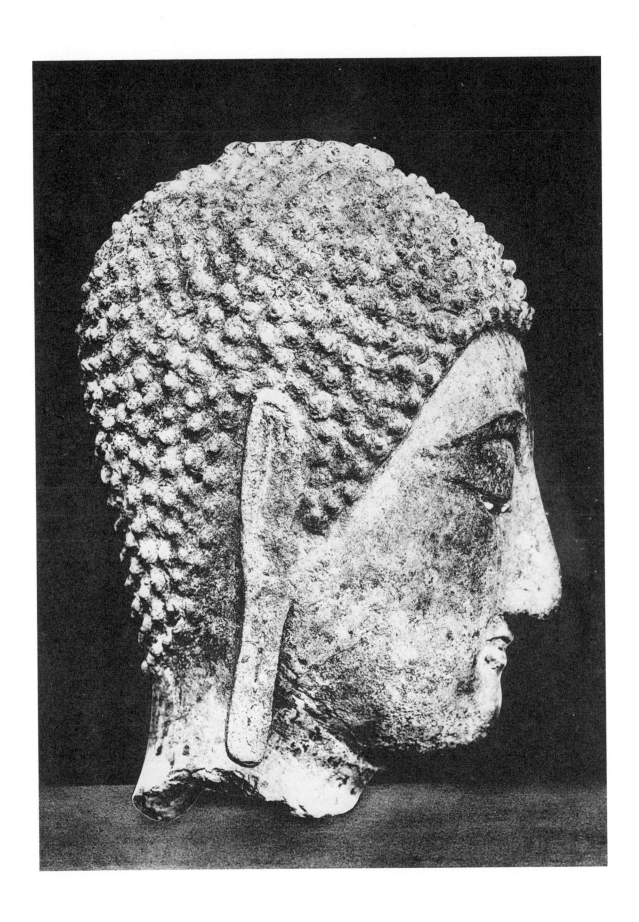

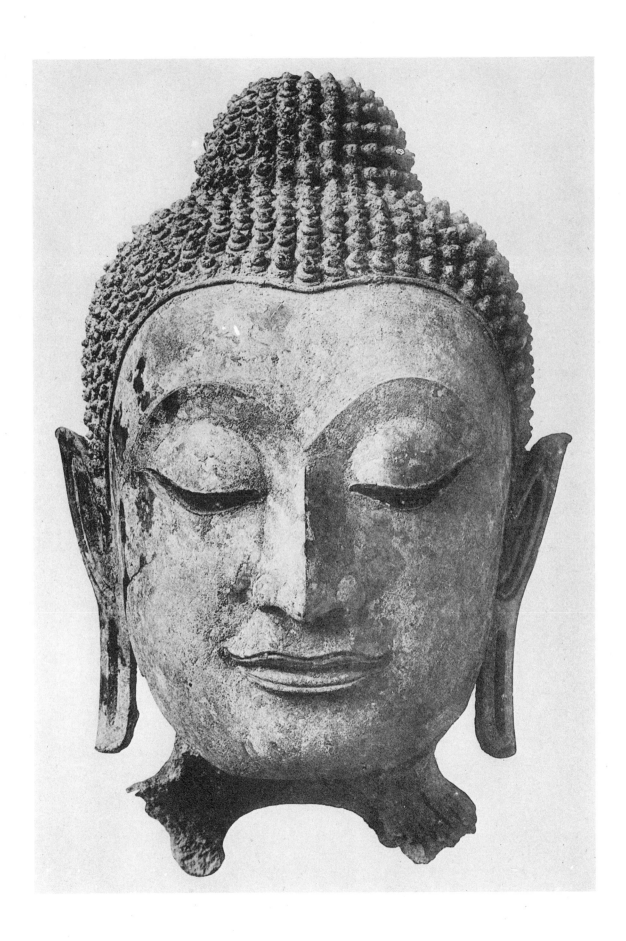

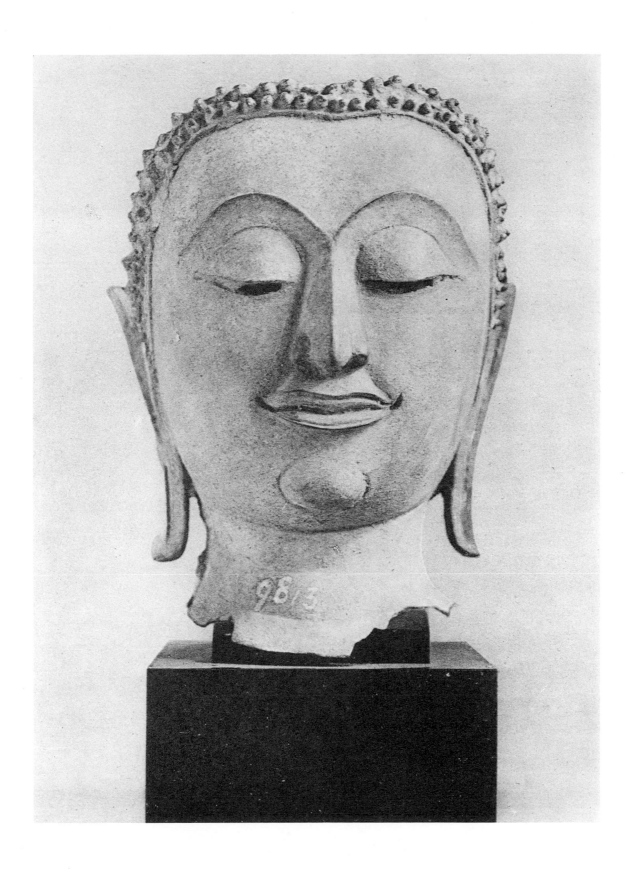

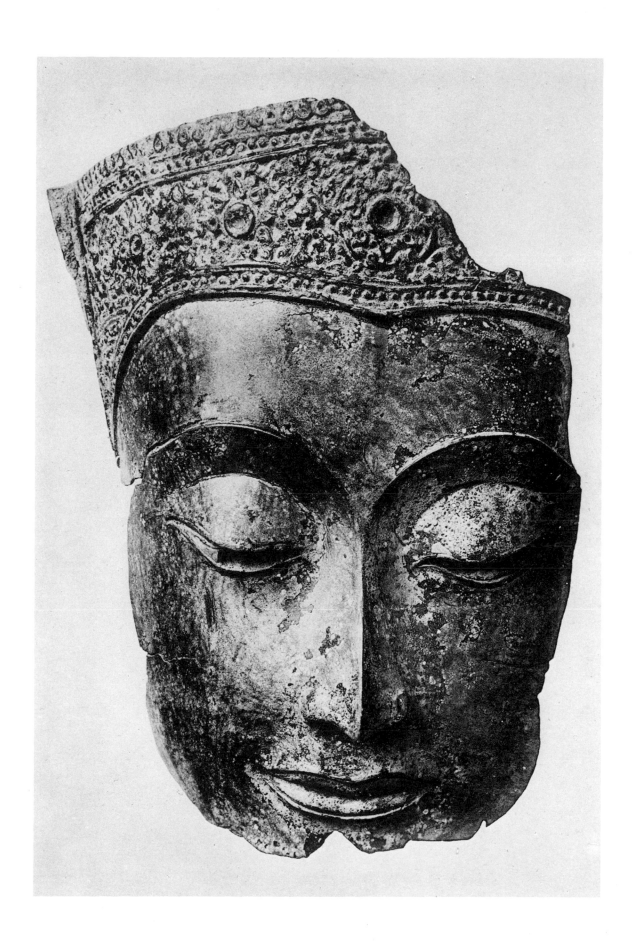

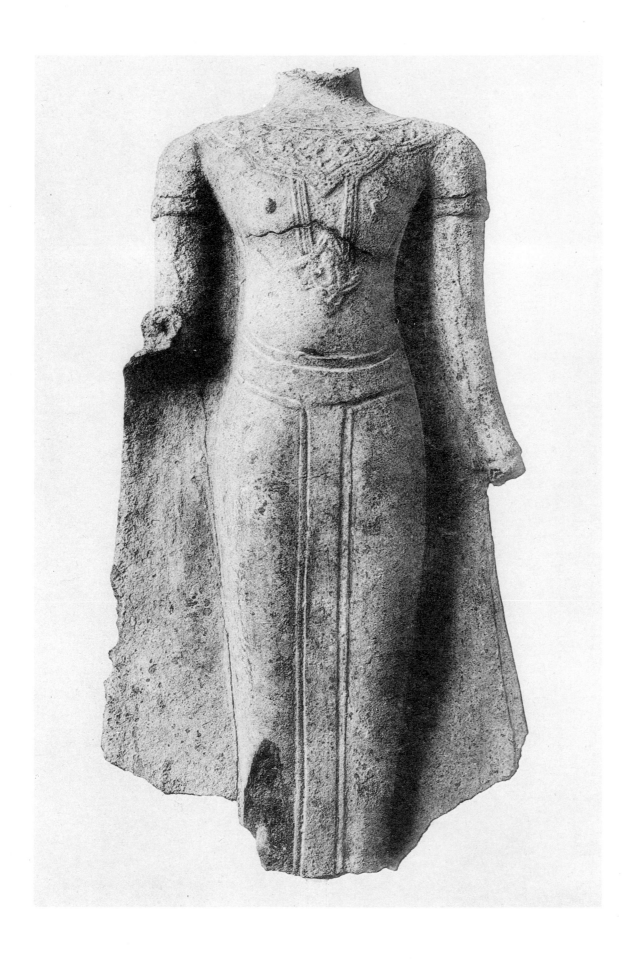

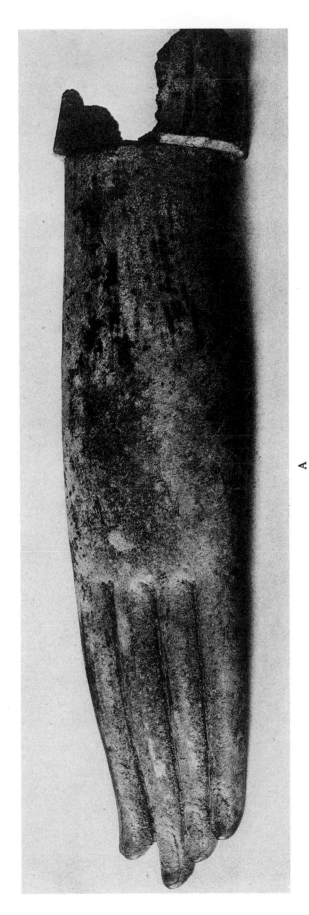

A

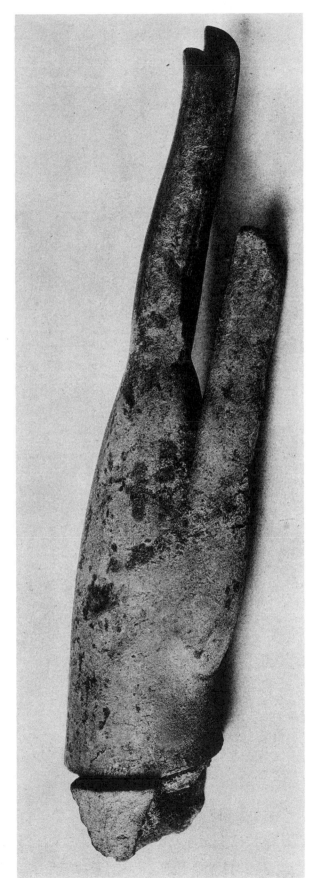

B

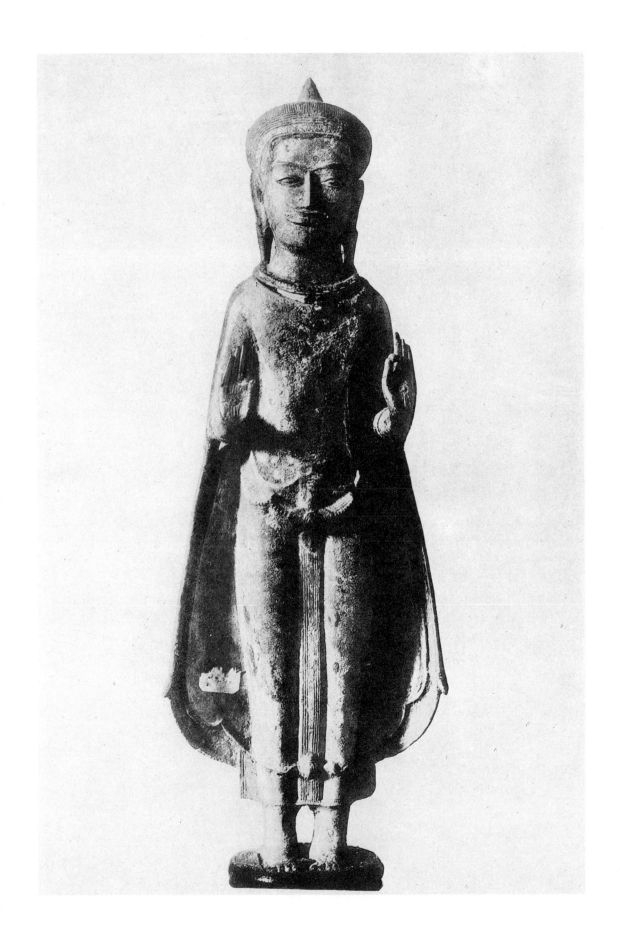

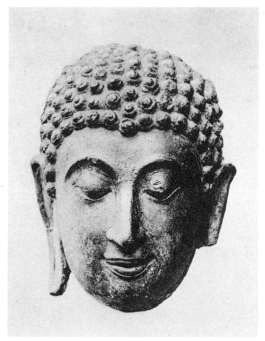

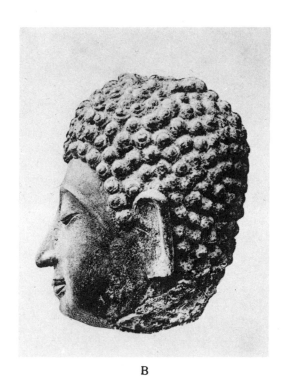

A

B

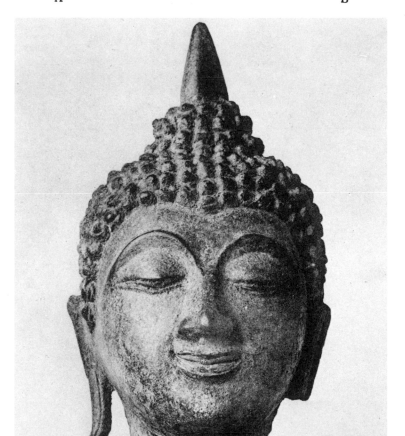

C

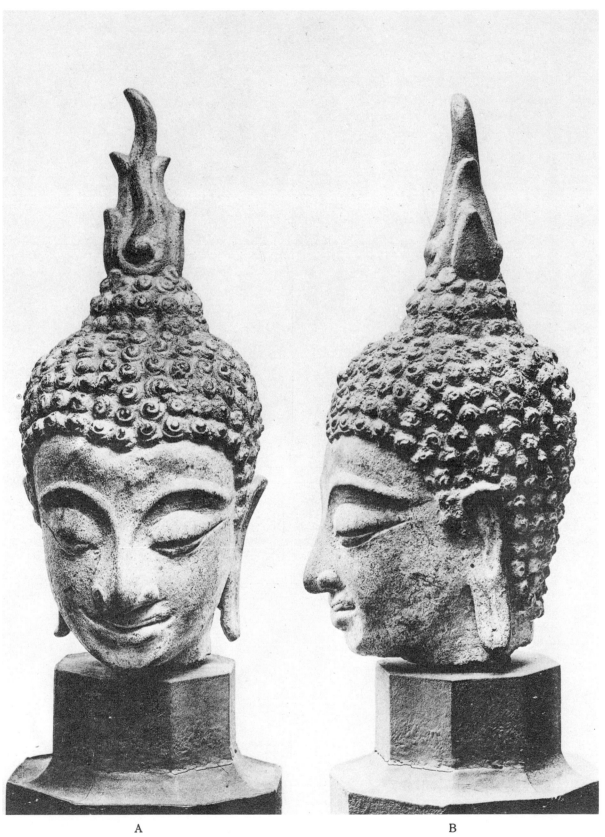

A B

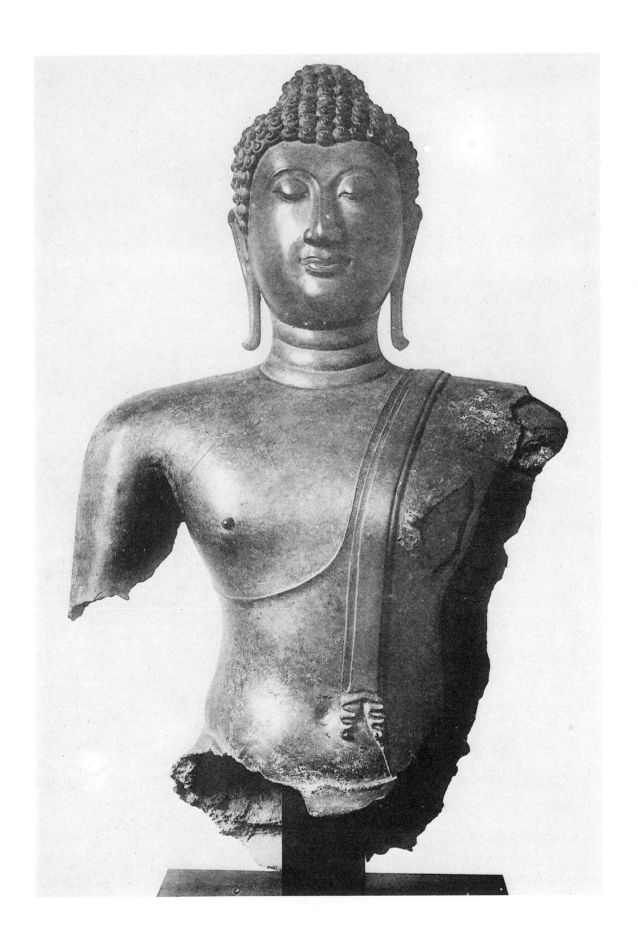

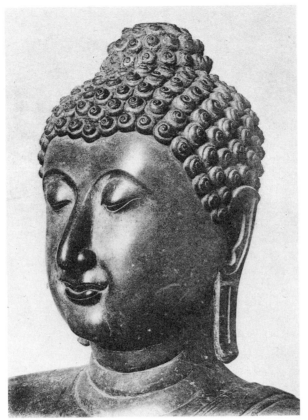

A

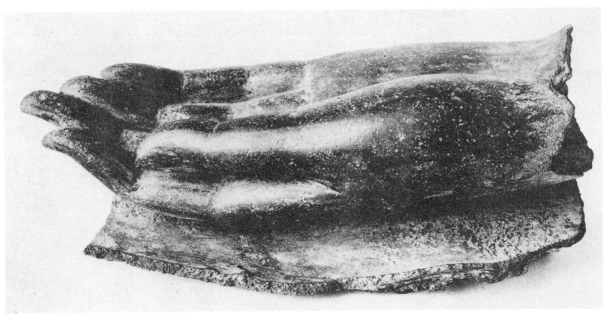

B

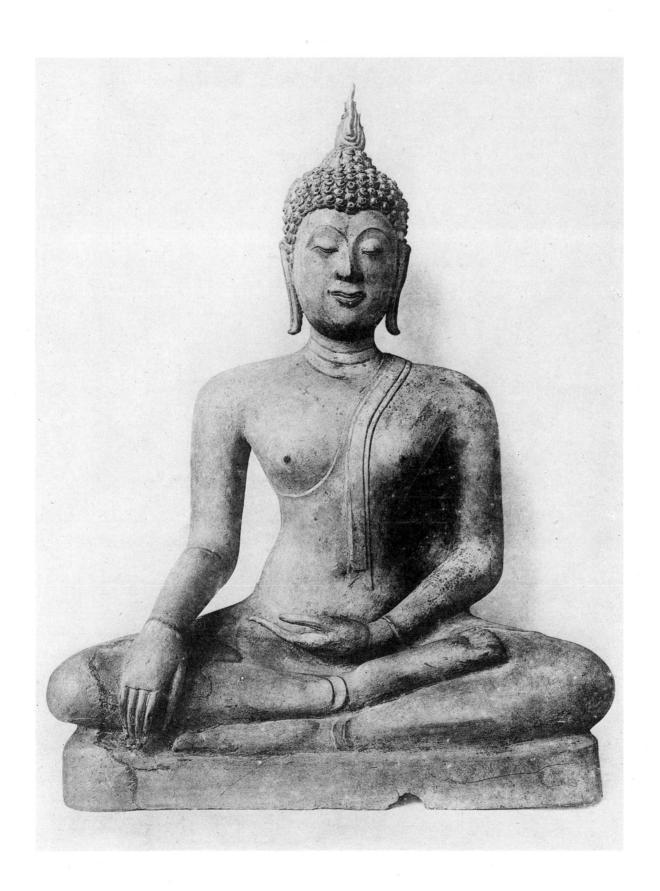

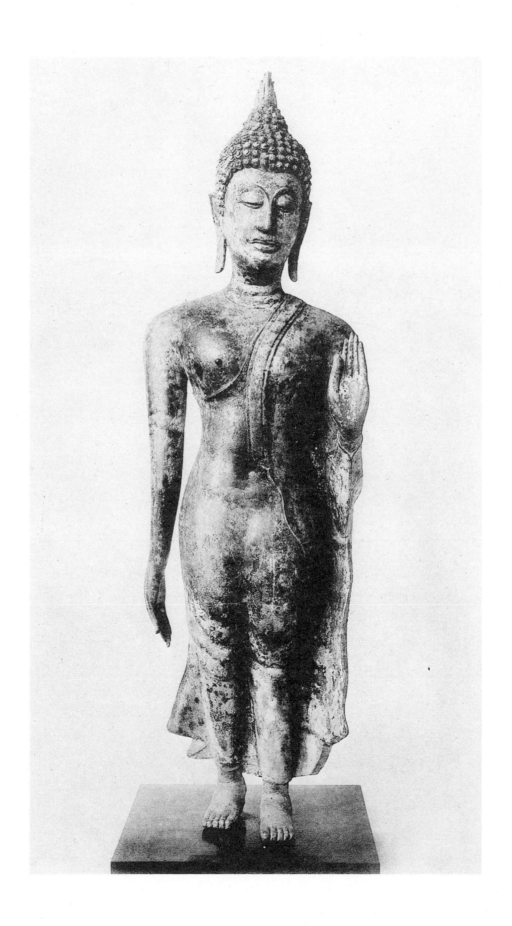

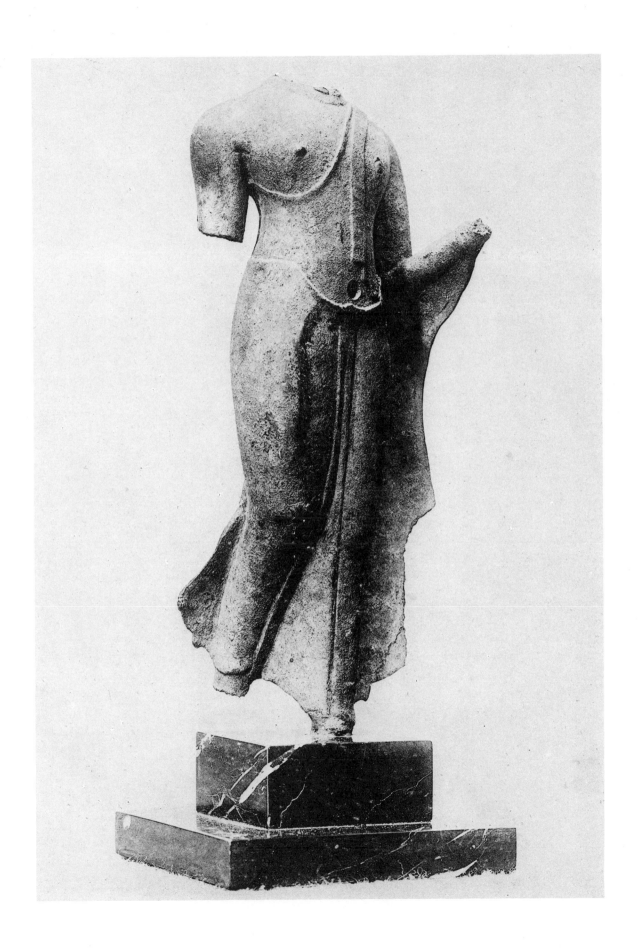

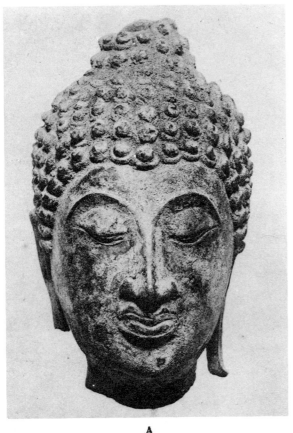

A

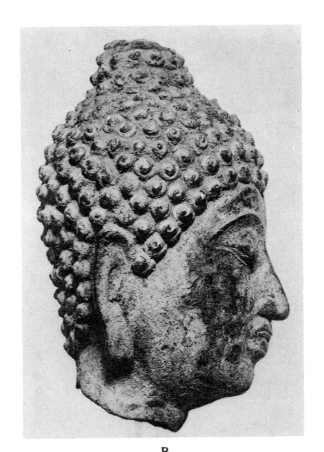

B

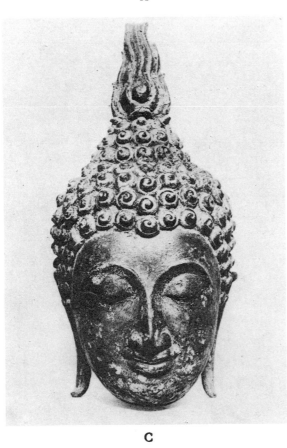

C

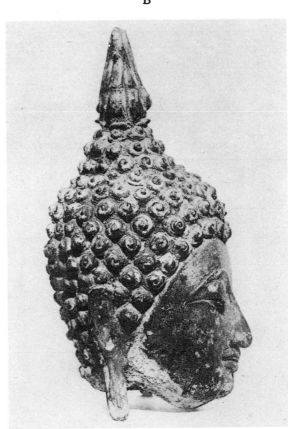

D

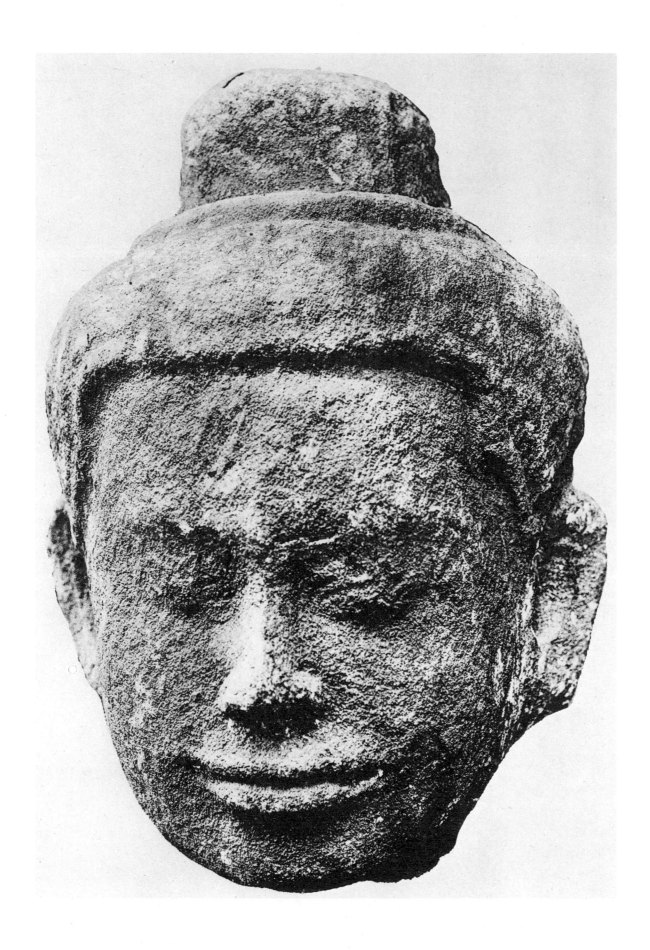

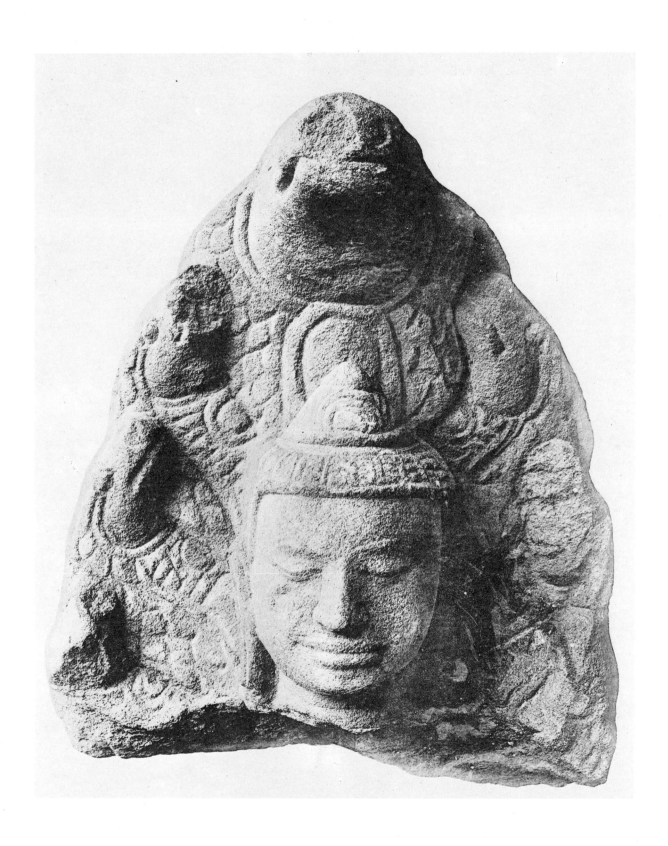

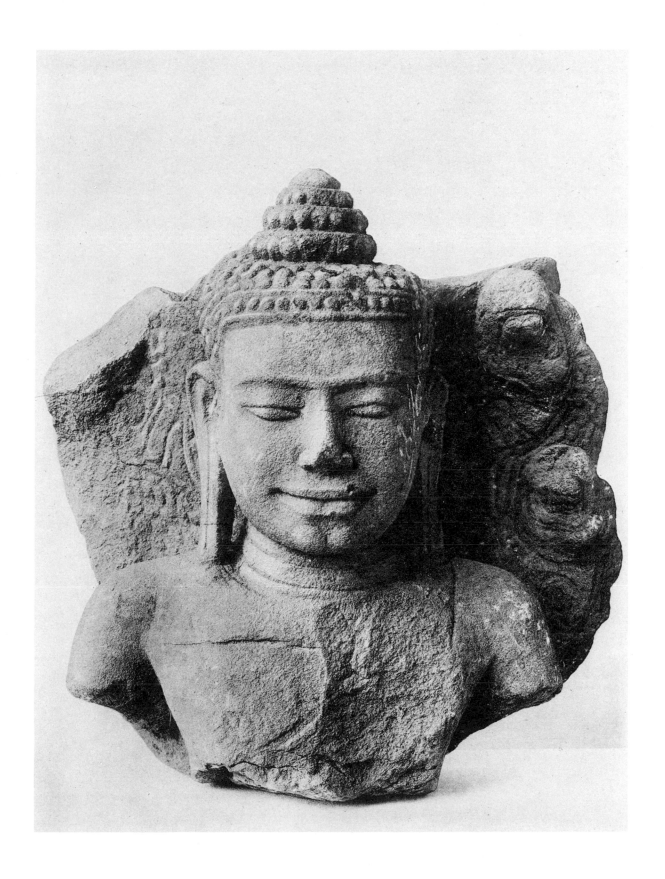

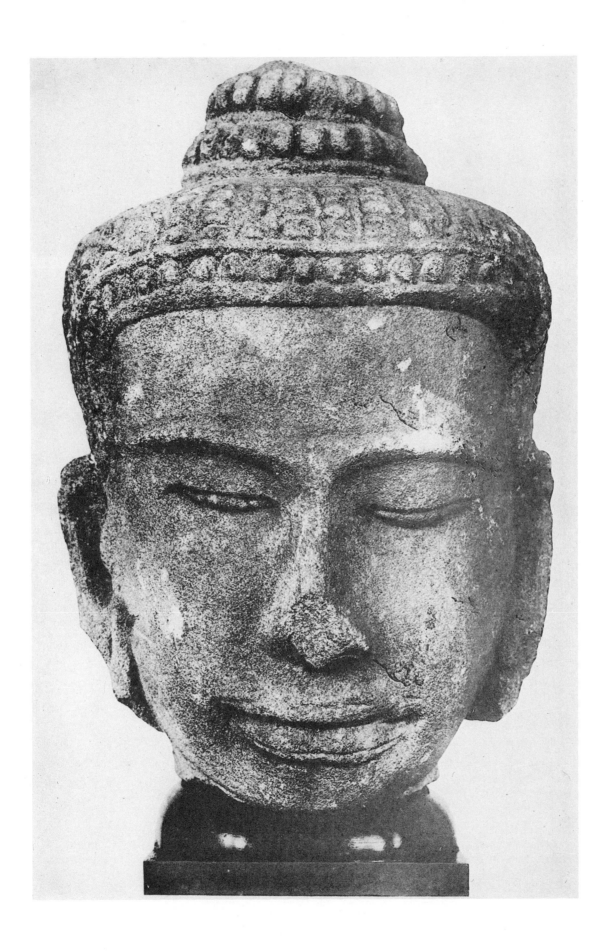

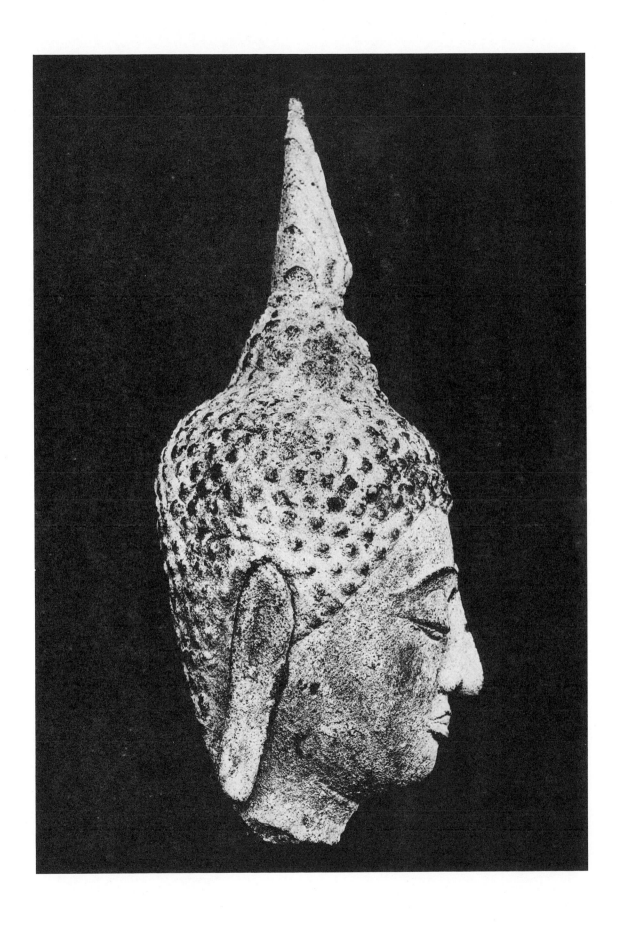

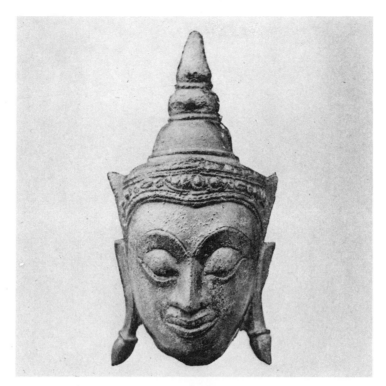

A

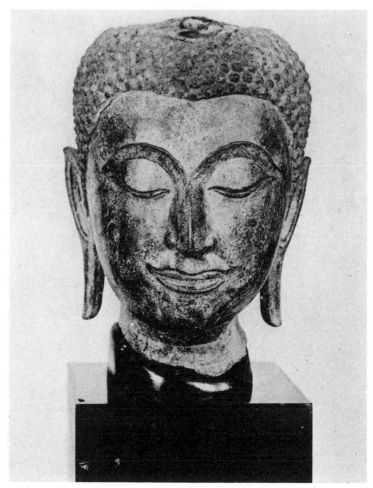

B

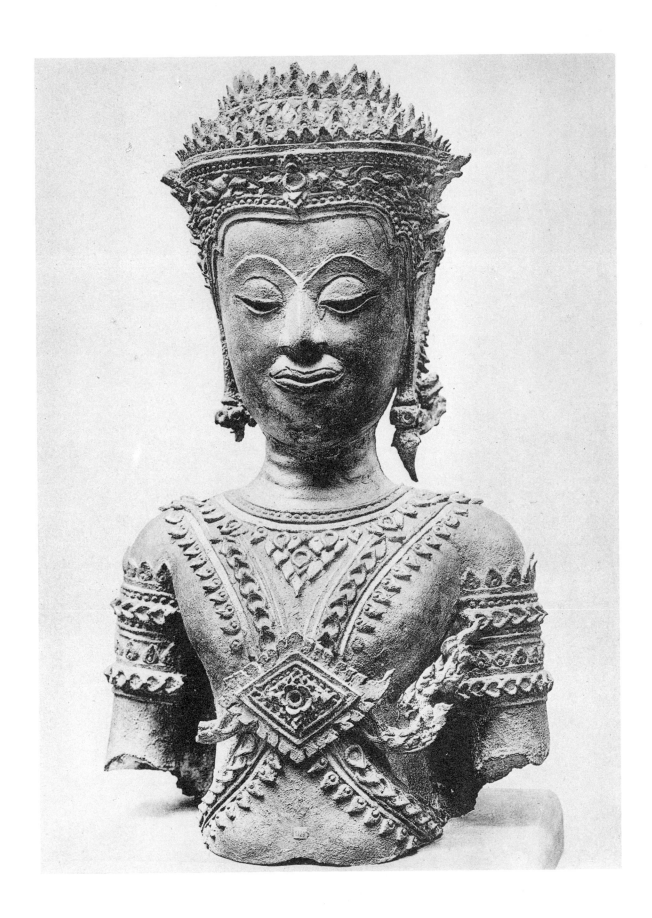

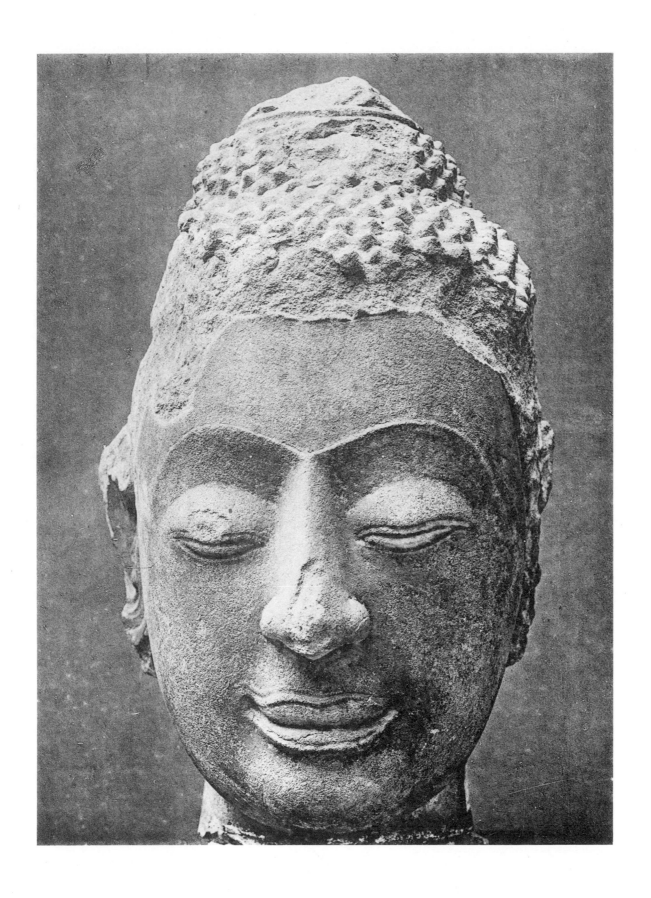

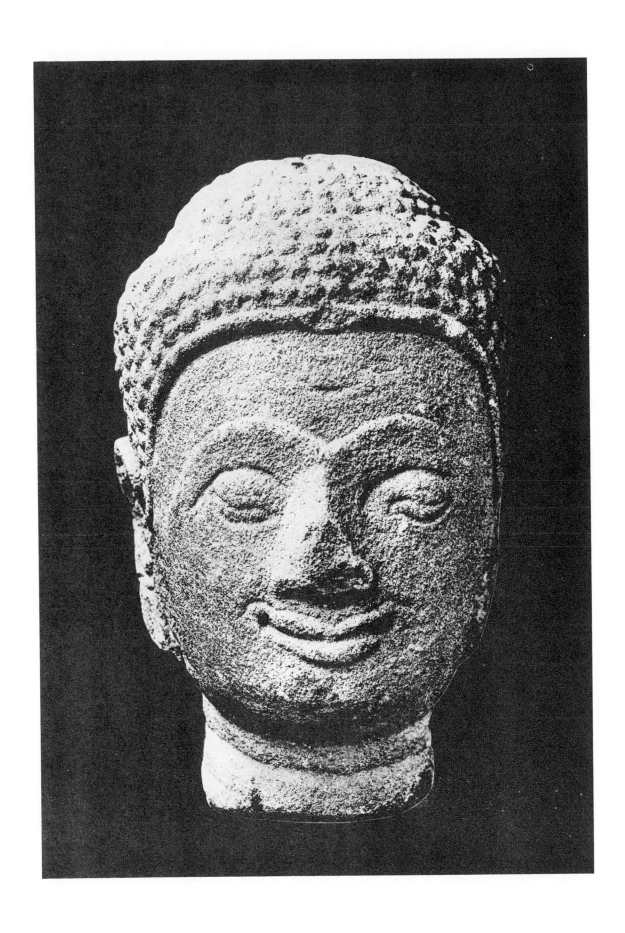

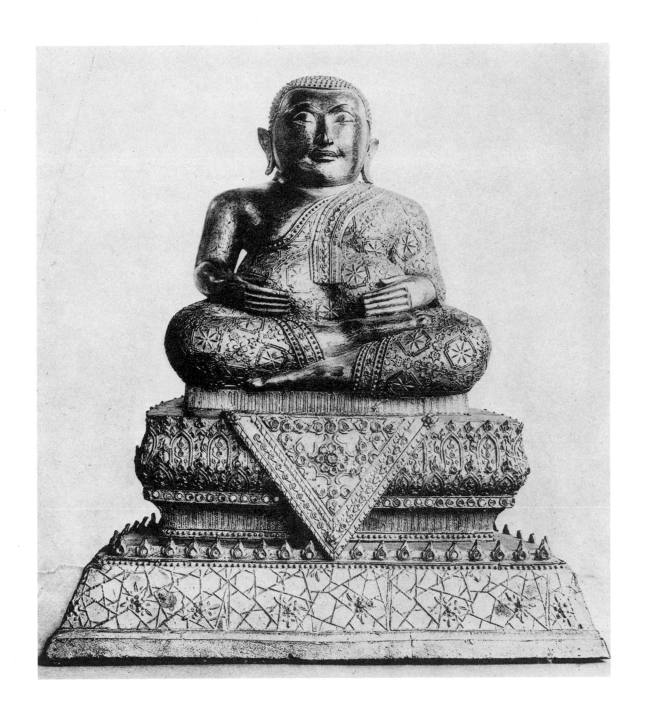

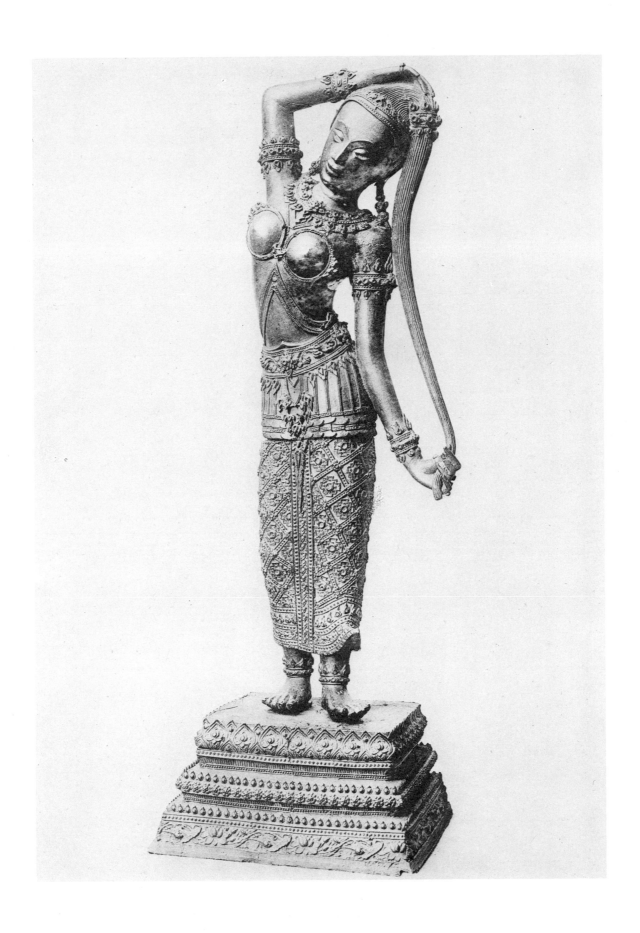

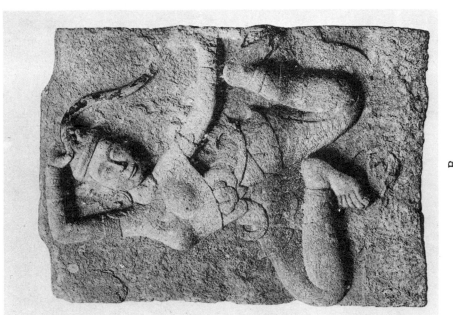

B

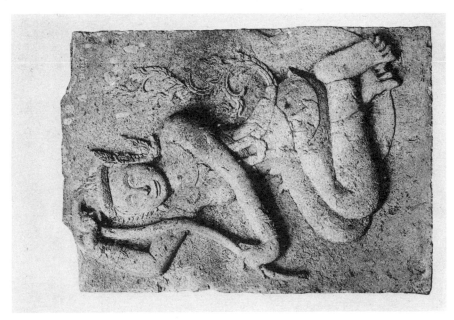

A

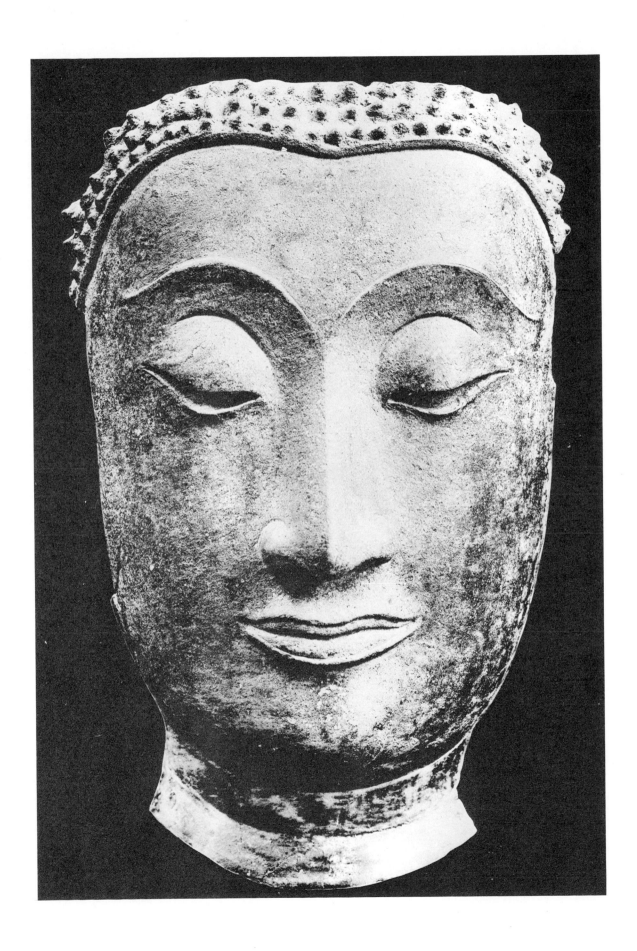

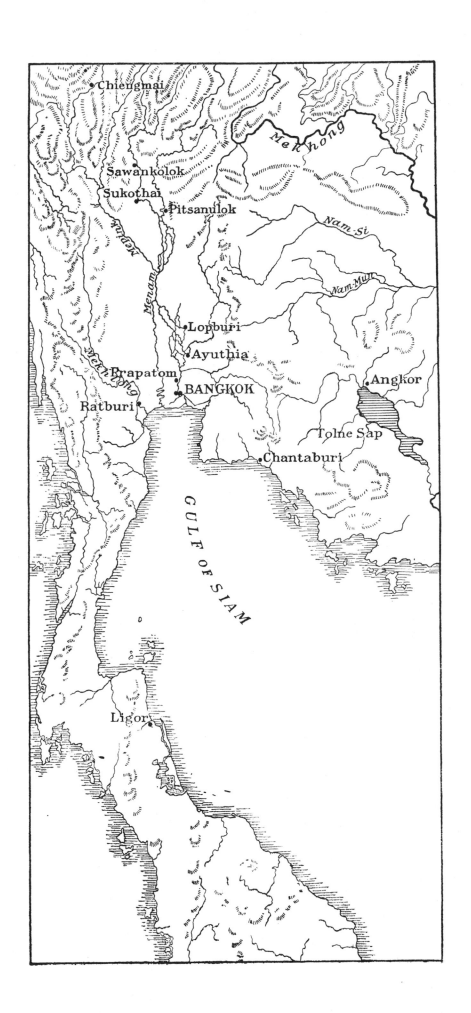

Lithographed in the U.S.A.
by Noble Offset Printers, Inc.
New York, N.Y. 10003